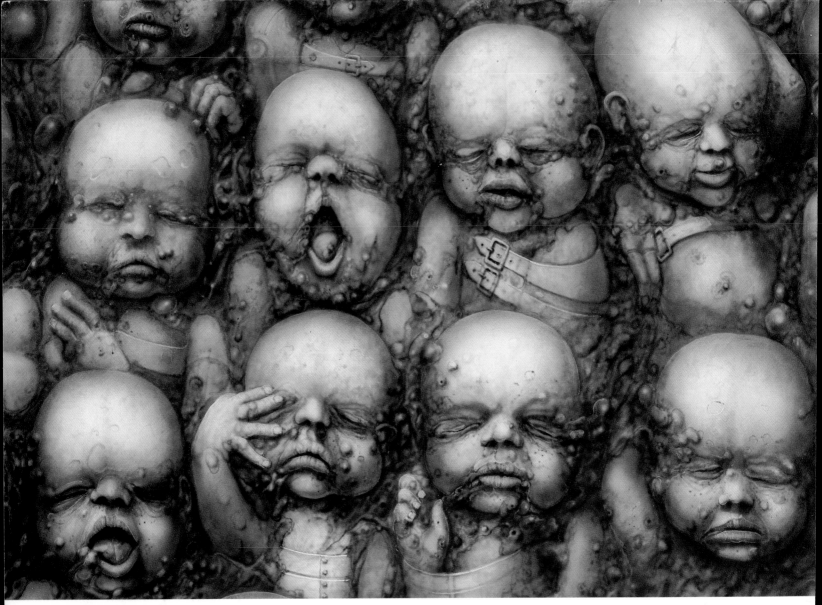

No. 215, *Landscape XVIII* (detail), 1973, acrylic on paper/wood, 70 × 100 cm

Cover:
Nr. 238, *The Spell II*, 1974
acrylic on paper/wood, 240 × 420 cm
Backcover:
Alien, from the film of the same name by Twentieth
Century Fox (all rights reserved)

s book was printed on 100 % chlorine-free bleached
paper in accordance with the TCF-standard.

© 1996 Benedikt Taschen Verlag GmbH
Hohenzollernring 53, D-50672 Köln
© 1991 H.R.Giger, Zurich
Edition and production: Gaby Falk, Cologne
English translation: Karen Williams, Hawkhurst
Layout: Mia Bonzanigo und H.R.Giger, Zurich
Colour artwork: Roland Gretler and Gaspare Honegger, Zurich
Black and white artwork: Louis Stalder, Lichtensteig
Cover: Peter Feierabend, Berlin

Printed in Germany
ISBN 3-8228-9642-x
GB

HR GIGER ARh+

TASCHEN

Foreword

I am sitting at my desk in my study in the Hollywood Hills writing this foreword. I look out the window and watch Barbara's rosebushes blooming, the twelve tall, slim Italian cypresses, the hill green with ivy. Our dog and cat play with each other on the lawn. The sky is blue.

Photographs of Giger's *N.Y. City* paintings are scattered around my desk. I examine them for the hundredth time, overwhelmed with admiration for this Swiss painter who is producing the great art of the 21st century.

What words can I use to describe these scientifically precise pages ripped out of my own body? Glance through this book yourself for a minute and sympathize with my dilemma. Our primitive, prescientific language contains few words accurate enough to communicate the scary, awesome facts this artist Giger reveals.

Giger, you slice my tissues into thin microscopic slides for the world to see.

Giger, you razor-shave sections of my brain and plaster them still pulsing across your canvas.

Giger, you are an alien lurking inside my body, laying your futique eggs of wonder. You have wound silken threads of larval cocoon around you and tunnelled down deep into my wisdom gland. Giger, you see more than we domesticated primates. Are you from some super-intelligent species? Are you a viral visitor staring with your petalled-poppy eyes into our reproductive organs?

August Kekulé von Stradonitz dreamed of the serpent eating its own tail, discovered the carbon ring and thus started the Golden Age of Chemistry. Einstein dreamed of floating in an elevator, understood the principle of relativity, and started the Golden Age of Physics. And here comes Giger. He has obviously activated circuits of his brain that govern the unicellular politics within our bodies, our botanical technologies, our aminoacid machines. Giger has become the official protrait photographer for the Golden Age of Biology.

Giger's work disturbs us, spooks us because of its enormous evolutionary time-span. It shows us, all too clearly, where we came from and where we are going. He reaches back into our biological memories. He takes baby pictures of us eight months before we were born. Gynecological landscapes. Interuterine postcards. Giger goes even farther back, probing into the nucleus of our cells. Do you want to know what your DNA code looks like? Glance ahead in this book. Are you ready to observe your RNA mass-producing cells and tissues, relentlessly cloning our fleshy architecture? Turn the page.

Like Hieronymus Bosch, like Pieter Bruegel, Giger mercilessly shows us the anabolism and catabolism of our realities. In these paintings we see ourselves as crawling embryos, as fetal, larval creatures protected by the membrane of our egos, waiting for the moment of our metamorphosis and newbirth. We see our cities, our civilizations, as insect hives, ant colonies peopled by larval crawling creatures. Us.

Giger gives us courage to say «hello» to our insectoid selves. Eugène Marais, the Boer naturalist, and Edward Wilson, the Harvard sociobiologist, have described the complex, intricate survival technologies of the social insects. From these ethologists we learn that social insects, termites for example, have been successfully running urban civilizations for over four hundred million years. From the social insects we are now learning the evolutionary strategies of intelligent species. If we want our species to evolve and grow, we must understand exactly how the social insects are superior to us. They have developed the tactic of metamorphosis – the individual passes through several stages each smarter and more mobile than the preceding. They use division of labor into temporal and structural castes. They develop winged forms which carry the DNA bible of the species aloft, migrating to new ecological niches. Egg intelligence organizes the hive (gene pool) into a harmonious, flexible, diverse unity.

The age of cities is over. Surely no free, intelligent person wants to spend life as a furtive, shadowed rodent running around in a caverned metropolis. Every city-dweller is an embryonic, slug-like larva waiting to metamorphize into a high-flying technicolored creature. Don't you?

Like it or not, we are all insectoid aliens burrowing within our urbanoid bodies. Giger's fleshscapes, his microscopic slides are signals to mutate.

City dwellers, alert! It is time to evolve! We shall no longer have to cling like barnacles and crawl like caterpillars in the darkness of our own metropolitan tissues.

Giger's art flashes the illumination of biological intelligence down into the dark cave of our cities. The genetic signal is clear. Crawl out of the city tunnels! Expose your pale membraned body to the sun and sky! Unfold your glorious, silken wings! Soar above the planet surface and fly high into space!

Here is the evolutionary genius of Giger. Although he takes us back far, deep into our swampy, vegetative, insectoid past, he always propels us forward into space. His perspective is ultimately post-terrestrial. He teaches us how to love our crawly, slimy, embryonic insect bodies so that we can metamorphize them.

Here in California we love Giger. We gave him our highest award for scientific achievement. The Oscar.

We love Giger because Los Angeles is not a city, we are post-urban. There are no subways in Southern California. Here we live in small space-like communities and neighborhoods connected with freeways.

Okay, I have written my tribute to the genius of Giger. Now I shall walk from my study out to the sunny patio.

The winged birds are calling me, a butterfly just zoomed by my window, and Giger is awaiting me up there above the trees where the sky is blue.

Timothy Leary, Hollywood, June 1981

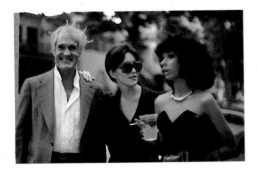

◁ Tim and Barbara Leary, Mia, 1980

▷ No. 358, *Illuminatus I*, 1978
acrylic on paper, 100 × 70 cm
(from left to right: Sergius Golowin, Timothy Leary, Goldapfel, Lovecraft + monsters)

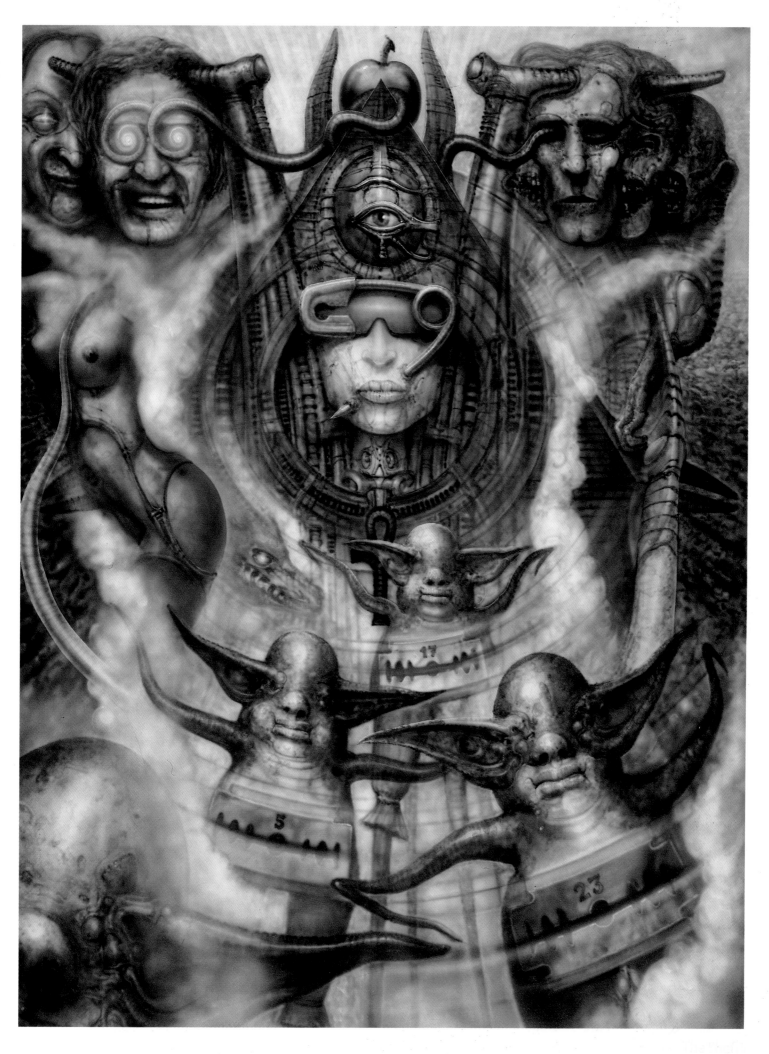

5

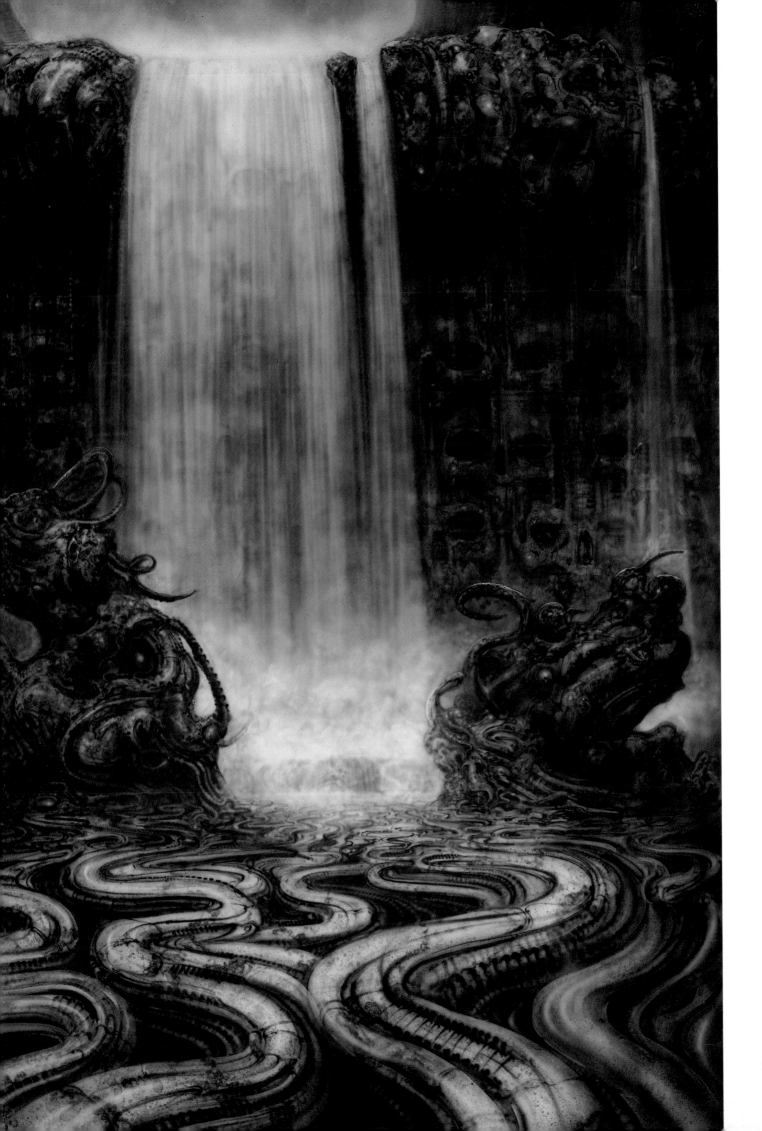

H.R. Giger
born 5 February 1940
in Chur

Abdul A Rh+

After a long journey, which took him from Chur across the Grisons Alps to the secret ski resorts of Flims, high up into the Grey Mountains and through magnificent valleys, across magical spaces littered with cable-cars and the Flem waterfalls in Segnes, he passed through Martin's Loch and far across the borders to Zurich, where for four years he studied the secret teachings of the Zurich School of Applied Arts. If he had appeared in broad daylight as a furniture salesman in Globus, Zurich, the prophecies of the Magus Willy Guhl would have been fulfilled.

Giger's Necronomicon

◁ No. 351, *Cataract*, 1977, acrylic on paper, 100 × 70 cm
No. 270, *The Lord of the Rings*, 1975, acrylic on paper/wood, 100 × 140 cm

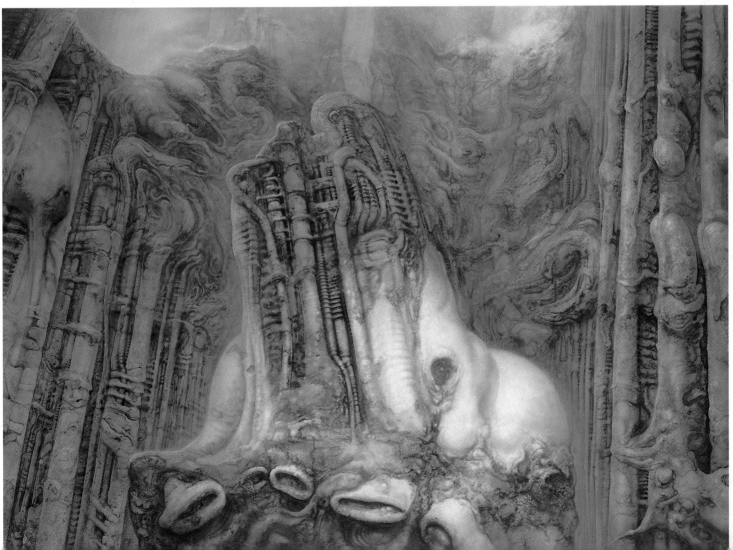

Memories of a Chur Childhood

I was attracted to the opposite sex from a very early age. The places that interested me most were the blackest. Hence, from the moment I was allowed to dress myself, I wore black. The darkest place in the house was under the table of a windowless room, which I made my playroom. There I played with my railway, bears and puppets, and with homemade weapons such as bows and arrows, knuckledusters, daggers and other fascinating objects.

I would have done anything for the fair sex. But the young ladies weren't the least bit interested in my toys. I was painfully shy, and often hid in the cellar or the stables. I was ashamed of the short trousers I had to wear, because I thought my thighs were too fat.

Among the most exciting events of my youth was the circus. The smaller and more intimate it was, the more the child entertainers thrilled me. Best of all were

H.R.G., Melly Giger, Dorli Goldner (war orphan) at the confederate riflemen's festival, Chur 1949

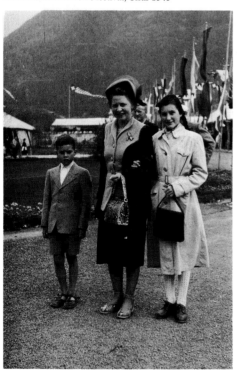

the turns on the trapeze and the high wire. Above all, it amazed me how the male athletes could hide their sex so well that they looked like girls. I went to almost every performance, using the endless variety of secret entrances that we children had to discover in order to get in without paying. Thus my place was usually underneath the seats of the audience.

I had a wonderful childhood, full of secrets and romantic settings. My parents let me play. The only nuisances were the domestic helps, some as dumb as they come, with their attempts at discipline and their compulsive tidiness. Even at kindergarten age I found some of the girls beautiful, and would stand in front of their houses for hours. But in kindergarten itself, talking to girls was highly disapproved of, and I was soon nicknamed a »lady-killer«. It was a Catholic kindergar-

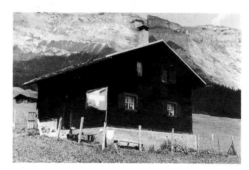

Holiday house in Flims-Foppa

ten with a lot of praying; if you were naughty, you were shown a picture of Christ's face streaming with blood and were told that you were to blame for his suffering.

When Fritz Billeter later once asked me why I so liked the sight of flowing blood, I suddenly realised where the sand-glass, or rather blood-glass (ill. p. 47) I'd built had come from. The bleeding head of Christ from the Catholic kindergarten was to blame.

Now back to Auntie Grittli's reformed kindergarten. On sunny days we would walk, holding hands, up to Rose Hill, where in the old days the Chur murderers used to be executed. There Auntie Grittli would give each little pair a »horse's harness« with a whip. Naturally the girls had to play the horses. It was rarely the other way round, and I relished the thought of the straps and whips. Body contact between us children took the form of scuffles. Because we were the oldest, my friend and I would be locked in the WC to give the others a ten-minute lead on the way back home. Sadly, it was consi-

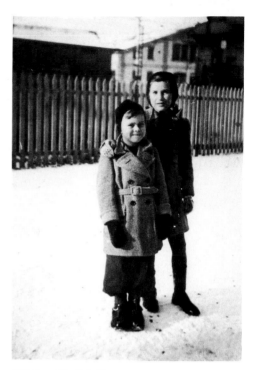

H.R.G. and Dorli Goldner, C. 1945

dered ungentlemanly to hit girls. I spent my six junior-school years at a »model school«, so-called because the teachers were themselves still in training. It was a wonderful school. I had no homework for six years. That was later to make the senior-school Gymnasium all the harder. My class consisted of six girls and myself. The girls were always inventing games which involved kissing. At the time I found this horribly embarrassing, and I made sure before every game that you didn't have to do any kissing. But the little hussies always found ways of frightening me.

The first three classes were all held in the same room, whereby one class was supposed to be taught aloud while the other two were studying. This was seldom the case. Everyone looked forward to the arrival of the new student trainees who had to play teacher to us. We made mincemeat of them, knowing they weren't allowed to hit us; that fell to the senior teacher, a real arsehole, who took the job all the more seriously. From the fourth to the fifth class we had a wonderful senior teacher called Wieser. He

8

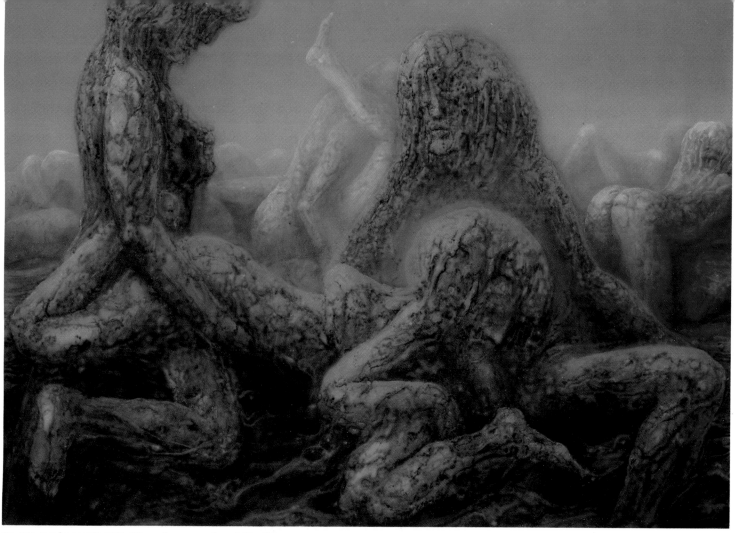

No. 208, *Landscape XV*, 1972–73, acrylic on paper/wood, 70 × 100 cm

No. 248, *Landscape XXVIII*, 1974, acrylic on paper/wood, 70 × 100 cm

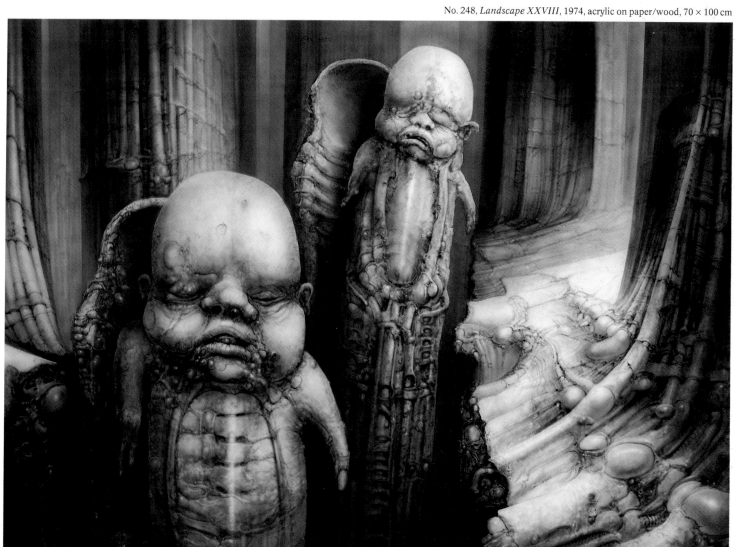

taught me modelling, drawing, set-building, etc. I assembled my entire railway set in the school's modelling room, and the children of my own and the other two classes, together with the teacher, would »play railways« on their hands and knees, with break-time sometimes being extended by half an hour. One day Wieser suggested having »a bit of a lark«. This consisted of racing two engines against each other without a collision until the stop-watch had expired. We developed an ingenious track system and each pupil had a set of points to work. Sometimes the engines almost brushed and we yelled with excitement, none louder than the teacher himself.

Sadly, he died of cancer while I was still a pupil, and – our having done nothing for five years – some idiot subsequently tried to prepare us with homework for the senior-school entrance examinations. We simply laughed. The fun went out of life after the sixth class. An endless horror of exams began. Things were no better at home, and my father had to experience at first hand how the children of scholars are often not the most clever. He tried to cram me with Latin in a crash course given in an increasingly loud voice. My mother sat beside me at the table and wept silently. She would usually do anything to see me happy, but in this case she was absolutely helpless.

Every year I changed subject to avoid repeating a class. But in the fifth year a bastard of a maths teacher failed me by half a mark. Repeating a year in Chur was something neither my father nor I could afford, and so it was off to Lausanne, where I received my first English lessons – from an Italian, in French. But English was the only thing I wouldn't have missed. No English, no film industry – and no Hollywood.

From top to bottom:
H.R.G. on an air-bed, 1961
Jazz in the black room, 1956
Jazz in the black room, 1956
H.R.G. and fellow students at boarding school, 1958

P. 11 top: No. 431, *Biomechanic Metempsychosis*, 1980, acrylic on paper, 70 × 100 cm

P. 11 bottom: No. 350, *Hommage à Böcklin*, 1977, acrylic on paper/wood, 100 × 140 cm

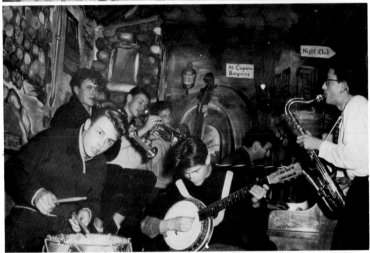

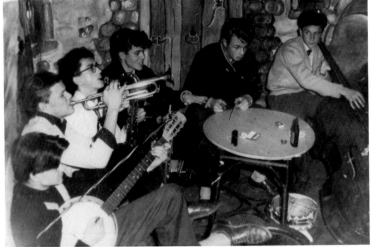

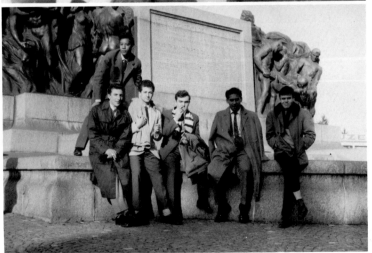

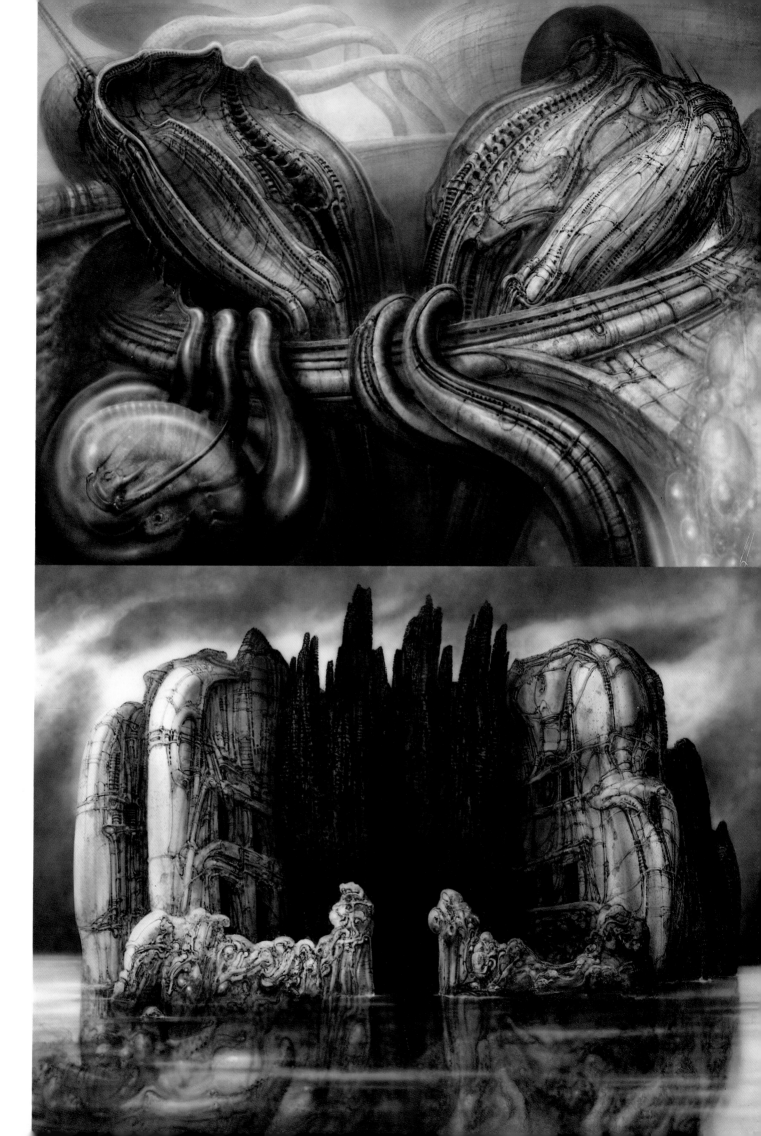

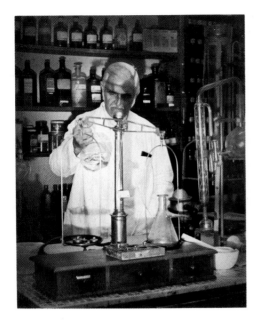

Dr. H. R. Giger in his pharmacy

Sketch advertizing his father's pharmacy

My Father

When I managed to persuade my father to give a short interview for the film *Giger's Necronomicon* shortly before his death in 1976, he began his statement thus:

»It astounds me that I should have produced a so-called artist. It can't have come from his mother's side.« Then he turned to my mother and said: »You're always so nervy and seeing ghosts.« To which my mother replied: »I may be nervy, but I haven't seen any ghosts – yet.« »Unprofitable« was my father's favourite adjective for art; he thought that contemporary art could never even earn you a basic living. For lack of good grades, therefore, I was sent at the age of eighteen – two years before my final *Matura* exams – as a trainee to a Grisons architect. This was prompted by my love of drawing and, in the event of bad times in the future, guaranteed me a safe profession: construction draughtsman. In Chur, Switzerland, the word »artist« is a term of abuse, combining drunkard, whoremonger, layabout and simpleton in one.

I really hardly knew my father. He was very introverted, very upright, helped anyone who got into difficulties and commanded respect as a doctor, pharmacist and president of the Pharmacist's Association and of the Alpine Rescue Service.

My father's pharmacy had both pills and leeches, which it was my job – as

errand boy – to deliver by bike to doctors and lesser mortals. To avoid the creatures dying in transit, the broad mouths of the bottles would only be sealed with gauze, fastened with a rubber band. It is not difficult to imagine the state in which such deliveries arrived. The leeches roughly cleaned of the worst of the road dust, all collected together again, half-dead in the bike pannier etc.

My father was an authoritarian but kind man who never hit me. Except for once. In his place, I would probably have murdered me.

The road near the pharmacy had been dug up yet again to lay power cables. By nightfall my booty was in the cellar – an approx. 6-foot length of copper cable with a lead sheath and a thick bitumen binding. I got my petrol blow torch working, first burning the tar and then melting the lead, which I subsequently turned into weaponry. The pharmacy's steel suppository moulds were ideal for making revolver bullets. The knuckledusters I cast in plaster moulds from wax models. Unfortunately, I had chosen as my work-

Father and son Giger

place the cellar underneath the pharmacy, which had no ventilating windows.

Utterly engrossed in my work – like an alchemist's *assistant* – and after hours of melting lead and burning tar, I suddenly heard my father's voice. On no other occasion did I hear him so incensed. I saw a white pharmacist's coat lunging at me through a thick, sooty smoke such as I knew only from the London fogs of Edgar Wallace. I rapidly grasped the situation and ran for my life. I nevertheless caught a few blows around the ears as I rushed past. I hid for two days. In that time the pharmacy had to be cleaned by every hand available. When my father – who had first thought the pharmacy was on fire – realised I was the culprit, his fear was replaced by anger.

Office, storeroom, poison cupboard, each room with its thousands of bottles – all were black. Everything was covered with a sticky, oily film. Anyone who knew our pharmacy can imagine how even today, years later, black bottles are still turning up as souvenirs of my alchemist activities. In terms of the hours of work put in by three female trainees, one errand boy, Mr Karst – the power behind the throne –, all the employees, my mother and my father, that lead was considerably more costly than gold. I often felt that my father, having worried himself almost to death about me, would – when I resurfaced fit and well – have preferred to see me half-dead or at least covered in blood.

I must have a guardian angel, because so far four people have shot at me and I've fired at someone once. In two cases the cartridges were dud and in three cases the bullet missed my head by a hair's breadth, despite having been aimed at me – naturally in the belief the weapon wasn't loaded.

It is sad that you have to keep your mouth shut about the things that are most exciting; you can never be sure whether they come under the statute of limitations or not. The older I become, the more nervous I get, because I believe that someone like myself can't be lucky all the time.

P. 13 top: No. 203, *Landscape X*, 1972
acrylic on paper/wood, 140 × 200 cm
P. 13 bottom: No. 207, *Landscape XIV*, 1973,
acrylic on paper/wood, 70 × 100 cm

H.R.G. shooting, 1953

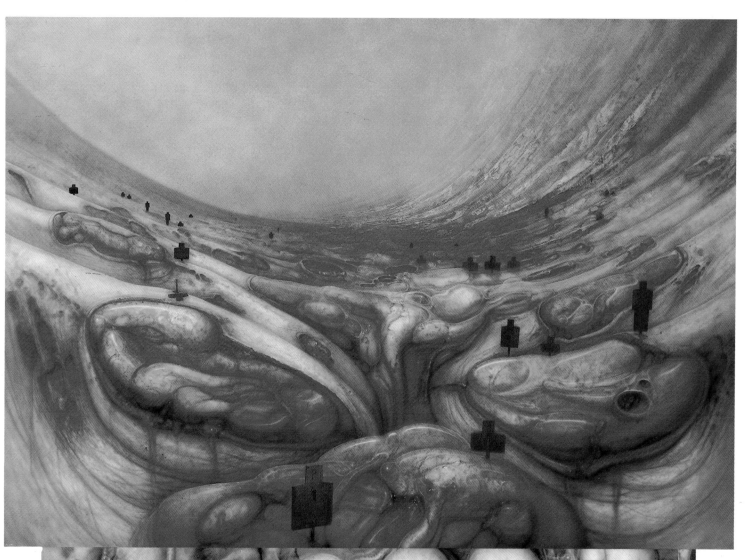

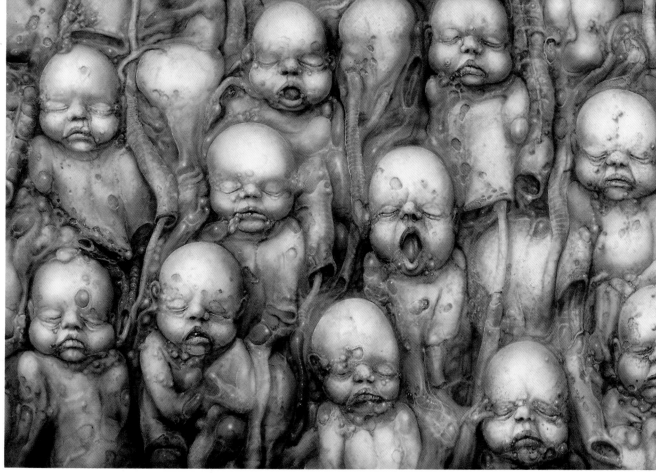

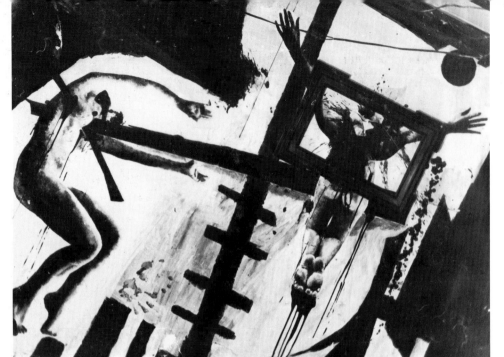

The black room, 1961

me as rather primitive. So I began to convert the top room, which was one floor above our apartment and which still contained my railway set, into the black room. I furnished it as a place for jazz sessions and seducing girls.

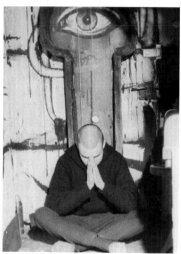

▷ No. 307, *Master and Margeritha*, 1976
acrylic on paper, 100 × 70 cm

Ghost Train

My customers were pretty girls, who naturally all got free tickets. The boys had to pay, as is still the way in amusement parks. It took considerable powers of persuasion to be allowed to push the little angels into the unknown (in small carts, from behind). I counted it my greatest success when I succeeded in enticing in an older, more mature girl. Sadly this happened only rarely.

Description of the ghost train:

My ghost train was a one-way ride which started at the entrance of Storchengasse 17 and led via a double hairpin bend to a swing-door, which was banged open by the front of the cart and subsequently pulled back into place by a spring. The dark, narrow corridor beyond, which ended in a left-hand bend, was crammed full of skeletons, monsters and corpses of cardboard and plaster. The low-voltage battery lamps, which we had stolen from the bicycles parked on the street and painted in different colours, gave out an eerie, spectral light. The ghosts – villains, hanged men and the dead arising from their coffins – were manipulated by my friends, accompanied by appropriate noises. The exit was in the back yard, which led out into the Scharfrichtergasse, an alleyway parallel to the Storchengasse.

After some three years at elementary school I began borrowing books by Karl May and Edgar Wallace. Later I moved on to thrillers such as *The Waxworks* and *The Phantom of the Opera*. After such impressive reading, my ghost train struck

H.R.G. in the black room, 1957

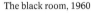

H.R.G. in the black room, 1960

The black room, 1960

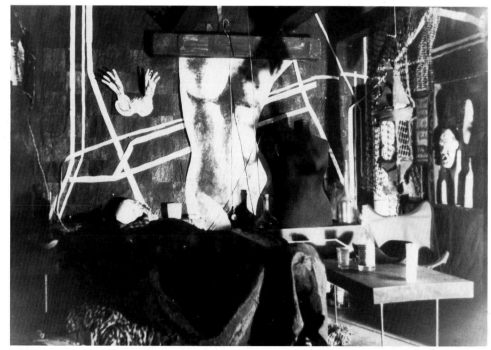

14

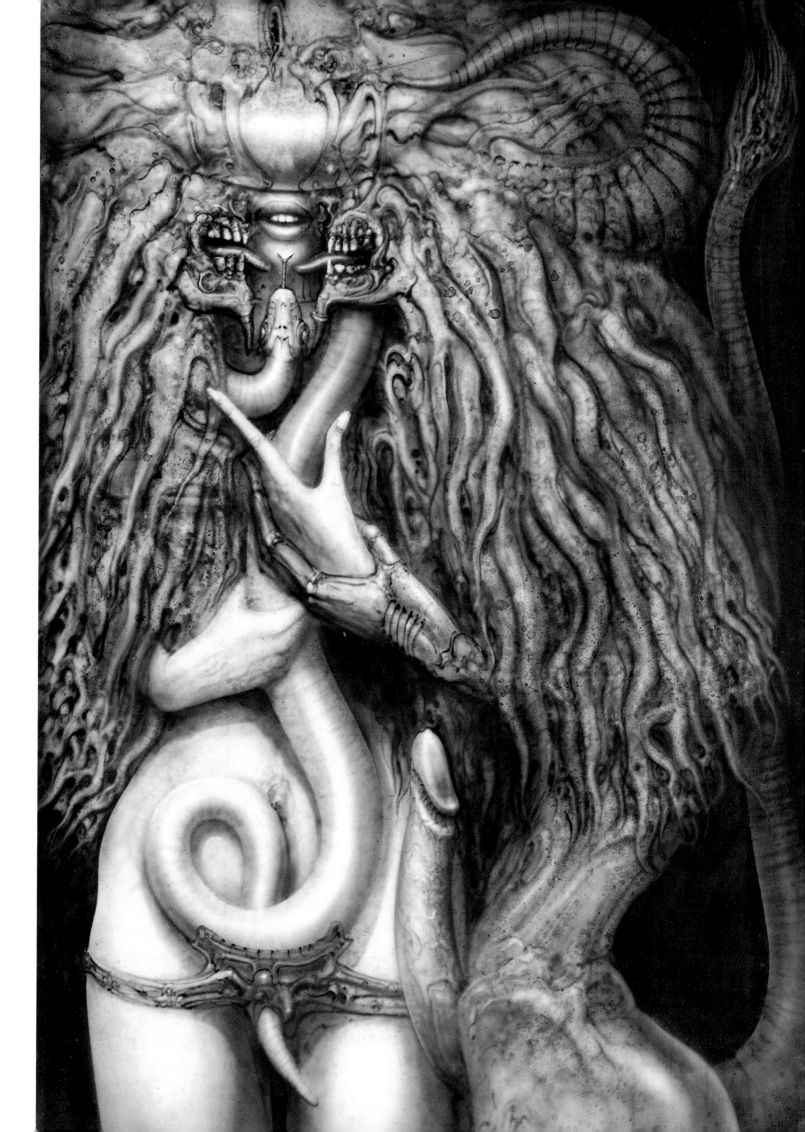

Underground newspaper, 1968, by Urban Gwerder

My First Publications

In 1959, the *Atomkinder* (Nuclear Children) which I used to sketch in the margins of plans were published in underground magazines such as *Clou* and *Hotcha* and in the Chur Canton school magazine. This didn't bring me any money, of course, but it gave me a great deal of satisfaction, particularly – after my ignominious academic career – in the case of the Canton school magazine. In the telephone book it still said interior designer. That was the safe profession my father had wished for his son. In years, however, no one has rung up about interior design. Thank goodness.

▷ Black room décor, 1957

First published works

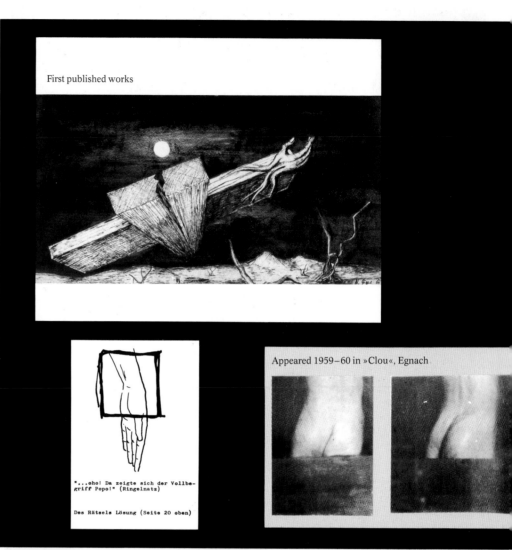

Appeared 1959–60 in »Clou«, Egnach

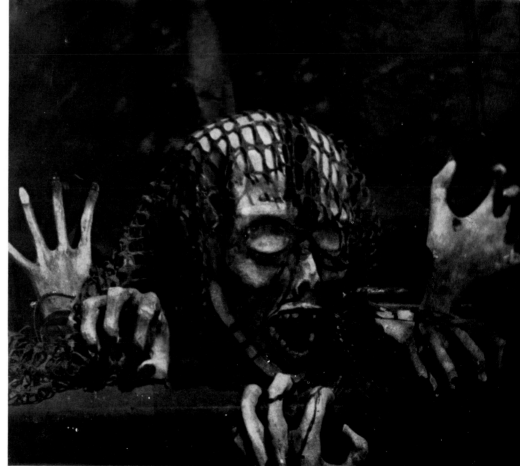

From left to right:
At the Lobau near Vienna, 1961, Photo: H.R.G.
Ink on transcop, 1959
»Clou«, 1961
»Clou«, 1961
Photomontage, 1960

H.R.G. in the black room

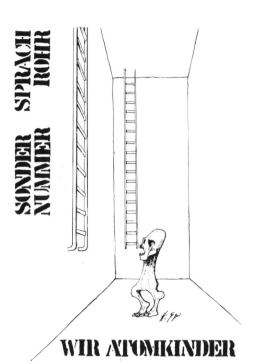

SONDER SPRACH NUMMER ROHR

WIR ATOMKINDER

We Nuclear Children

We are grateful to our creators,
who, at the sound of the big bang,
in accordance with Swiss nuclear regulations,
threw themselves reflex-like to the ground
and bravely counted to fifteen,
for otherwise we wouldn't be here at all.

We nuclear children don't want to moralize,
reproach anyone,
we simply want you
to get used to us and grow fond of us.

But we can't guarantee you anything,
for as soon as we're in the majority,
you will count as abnormal
and will perhaps have to suffer for it.

H. R. G. 1963
opposition / democracy live

Kritische Monatsschrift für Politik und Kultur

Critical political and cultural monthly magazine
H.R.G., 1963

das sprachrohr

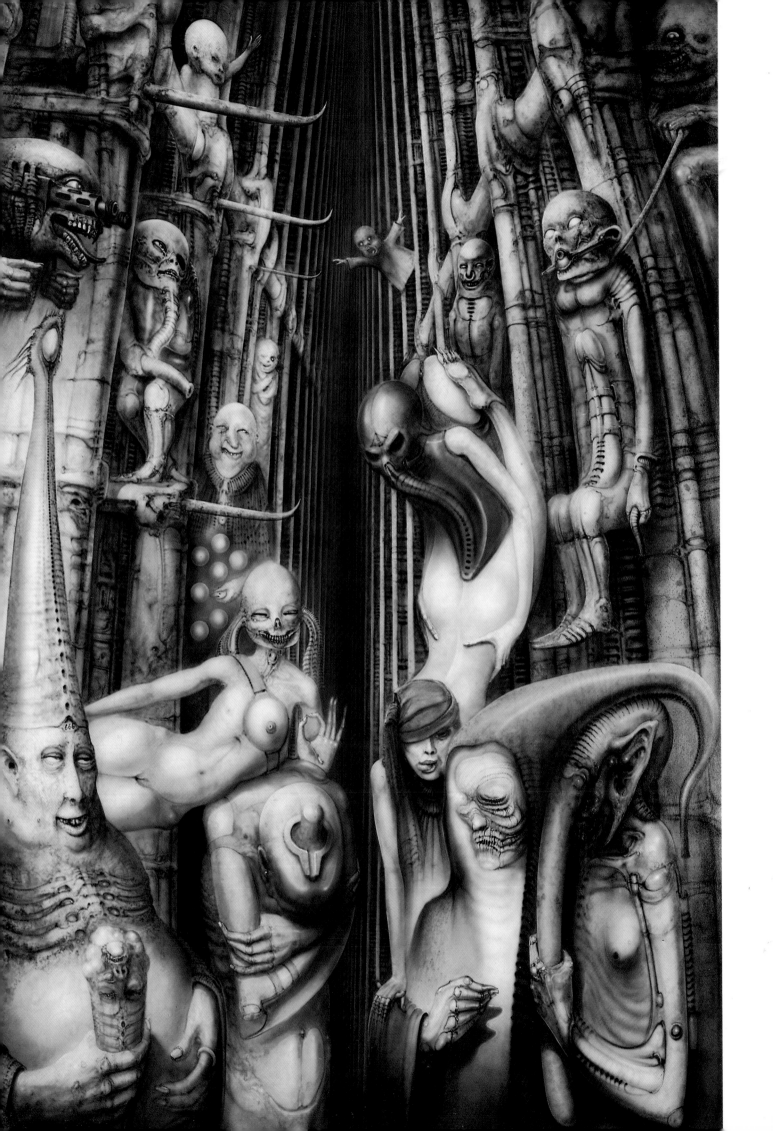

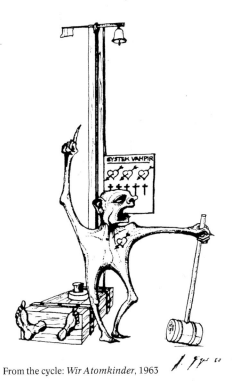

From the cycle: *Wir Atomkinder*, 1963

◁ No. 274, *A. Crowley* (The Beast 666), 1975
acrylic on paper, 200 × 140 cm

Try Your Strength – Hit Lukas!

A »Hau den Lukas« – »try-your-strength« machine – is a familiar sight to every fairground visitor. A box with a bolt which, at the blow of a sledge-hammer, shoots a weight up a 4-metre-high slide. Hit with sufficient strength, it strikes a bell at the top. In a drawing of 1986 I subconsciously combined this machine with a guillotine.

This »Hau den Lukas« reminds me of a story from my youth – in Chur, of course. It was the confederate riflemen's festival, which took place in Chur shortly after the War and which caused a tremendous stir in the sleepy town. It stuck in my memory because my sister, who was appointed a target recorder, was sick for three days – like everyone who got a so-called »water« sausage for their services. All the festival participants and half the town were ill after eating one of these sausages. The »water« sausages were supplied by the largest and best-known butcher in the town, whose paterfamilias was – significantly – called Lukas. The scandal was naturally satirized in the next carnival programme, and indeed in such an atypically original way that the idea can only have come from outside. »Hau den Lukas« literally means »hit Lukas«, and thus it was that a float with a small podium was equipped with one of these machines. In place of a sliding weight, the sledge-hammer here activated a huge fork. Instead of sounding a victorious chime at the top, this huge fork pricked a drooping sausage hung where the bell should be. This in turn sent a sizeable quantity of water spouting into the tub stationed on the far side of the »Hau den Lukas«, in which red-haired bathers were splashing about.

Wonderful.

It was unfortunately all too much for the red-haired butcher, and he now did precisely what made him so unforgettable. He dispatched his butcher boys to destroy the inglorious exhibit. The sabotaged float was nevertheless included in the procession and everyone could imagine how it worked. Two horses pulled the float with the damaged »Hau den Lukas«, its slide rail hanging down and the empty sausage skin dragging along on the ground behind, garnished with the red wig of the – now beaten-up – wielder of the sledge-hammer.

A truly powerful impression which lodged in the memory of every Chur carnival-goer. The object was a forerunner of American Pop art, a *Ghostly Vision* by Claes Oldenburg.

Ink drawing, 1961

The Guillotine

All we really know of the drop-blade method of execution is that Dr. Guillotin improved it; he replaced the horizontal blade with the angled knife, which no longer hacked but neatly sliced.

The inventor was one of the first to benefit from his invention. As a child I regularly read a thriller called *The Waxworks*; it went hand in hand with my passion for ghost trains. In a bookshop one day I suddenly spotted a work on the Paris waxworks. It became my favourite book. A Swiss lady from Bern called Marie Grossholz moved to Paris to marry a Mr. Tussaud. Together they founded the first waxworks. They modelled VIPs and criminals as well as ordinary mortals. For the real degenerates there was a Chamber of Horrors in the basement, as in London. In my thriller these figures were corpses who had been preserved against decay with wax and various herbs and therefore looked particularly real. During the French Revolution Madame Tussaud modelled the VIPs of the Revolution on her own, her husband having died in the meantime.

The young woman had rented a studio very near the Place des Grèves. A few paid assistants reported everything to her and stole the heads and, frequently, the clothes of the victims from the Place des Grèves, on which half of Paris lost its head. From these heads she made death masks, which she then filled with wax. She employed several assistants since the public always wanted to see the latest victims. Thus the unfortunates who lost their heads on the Place des Grèves one day could be admired in wax the next – most of them still wearing their original clothes.

The entire waxworks was subsequently destroyed during a huge blaze. As if by a miracle, however, both the Chamber of Horrors and the Torture Chamber with its guillotine survived in all their monstrous glory.

Madame Tussaud moved to London and opened her waxworks in Baker Street. She was herself cast in wax after her death and placed in an old cashier's booth, where short-sighted visitors still address her somewhat dusty figure today. I once managed to purchase a plastic kit of a small guillotine, but that still didn't satisfy me. I wanted a life-sized version. So I had a carpenter cut out, according to my sketches, all the necessary parts to the original scale. Only the blade was still lacking. My father thought I was mad.

I never put the machine together because I suddenly lost all interest in beheading the window dummies which stood silently around my black room. Being made of plastic, it would have been possible to cut off their heads and stick them back together again right away.

H.R.G. in front of the Zurich Kunsthaus, 1977
Photo: Candid Lang

▷ No. 344 *Mirror Image*, 1977
acrylic on paper/wood, 100 x 70 cm

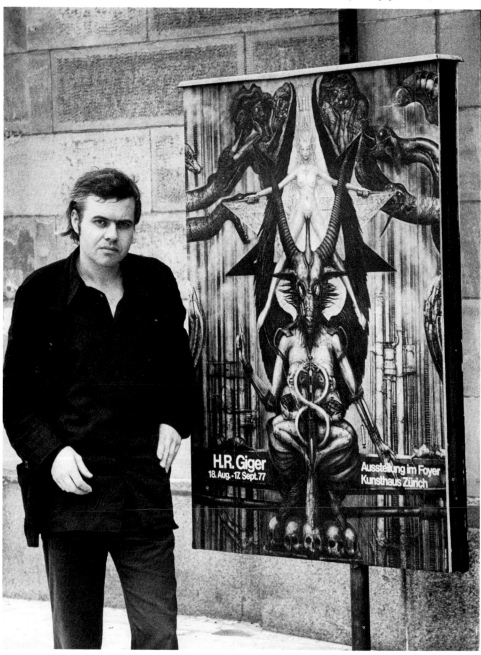

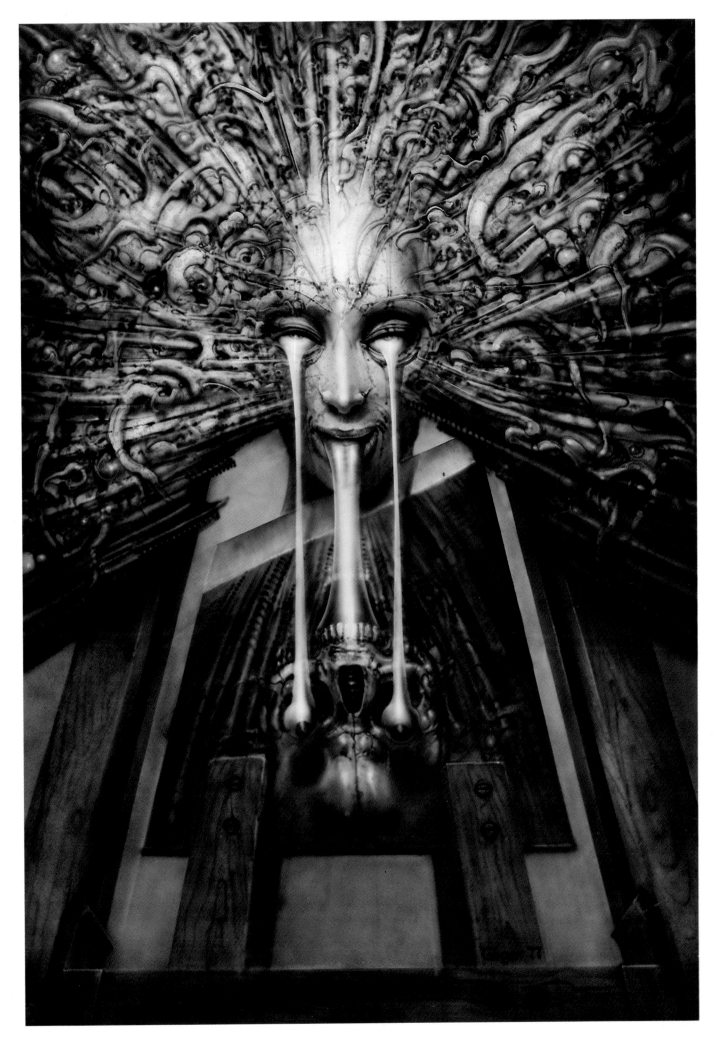

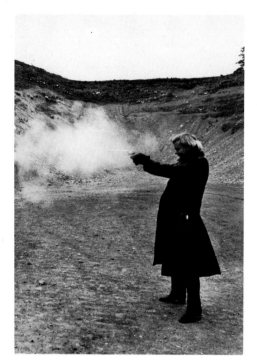

H.R.G. shooting in the Kaiserstuhl gravel pit, 1984
Photo: D. Margot

My First Lecture at the Chur Gymnasium

My first lecture at the Chur Gymnasium, on a subject of my own choice, was naturally on the history of the revolver. I stood up in front of the class utterly unprepared and knew only that the word revolver came from the latin *revolvere*, in other words to revolve or roll. I also knew

that Samuel Colt had been the first to invent this 6-round hand-gun with a revolving barrel, for self-loading with priming cap, gunpowder, seal and lead bullet. The lecture was brief, since after these few words I got out my weapons collection. I had brought along some 20 different pistols and revolvers, which I now handed out to my fellow students. Everyone began aiming at everyone else. The teacher went pale and, in the tumult that followed, sought in vain to collect in the dangerous objects. That was my shortest lecture.

Because they can kill, revolvers and pistols immediately make you think negative. But they can also fascinate you, as they fascinated me as an 8-year-old boy.

I was particularly struck by a small Mauser pistol of my father's. Pistols are especially dangerous, because you can't tell from the outside whether they are loaded. Even when the magazine is empty, there may still be a bullet in the barrel.

In 1984, after 30 years' abstinence from weapons, I bought myself a revolver and a Pumpex after having a nightmare; about 2 years ago I was very nearly shot by a stranger in my bedroom. I thus believe the L.A. statistics that four out of five of owners of an »anti-burglar« weapon are shot by it themselves.

P. 26: No. 305, *Safari*, 1973–76
acrylic on paper/wood, 100 × 70 cm

P. 27: No. 620, *Pump Excursion III*, 1989
acrylic on paper/wood, 100 × 70 cm

Noracyclin, 1965, transcop, 30 × 21 cm

Supermarket, 1965, transcop, 30 × 21 cm

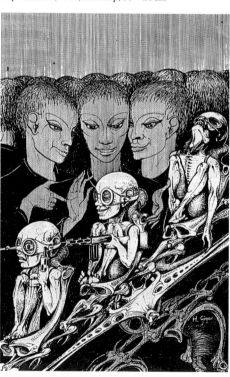

From the cycle: *Wir Atomkinder*, 1963

▷ No. 295, *Samurai*, 1976
acrylic on paper/wood, 100 × 70 cm

Child-Bearing Machine (2nd version) 1965
transcop, 30 × 21 cm

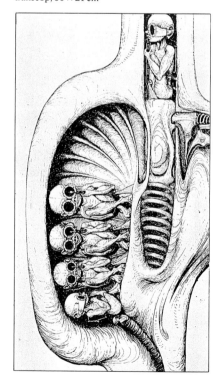

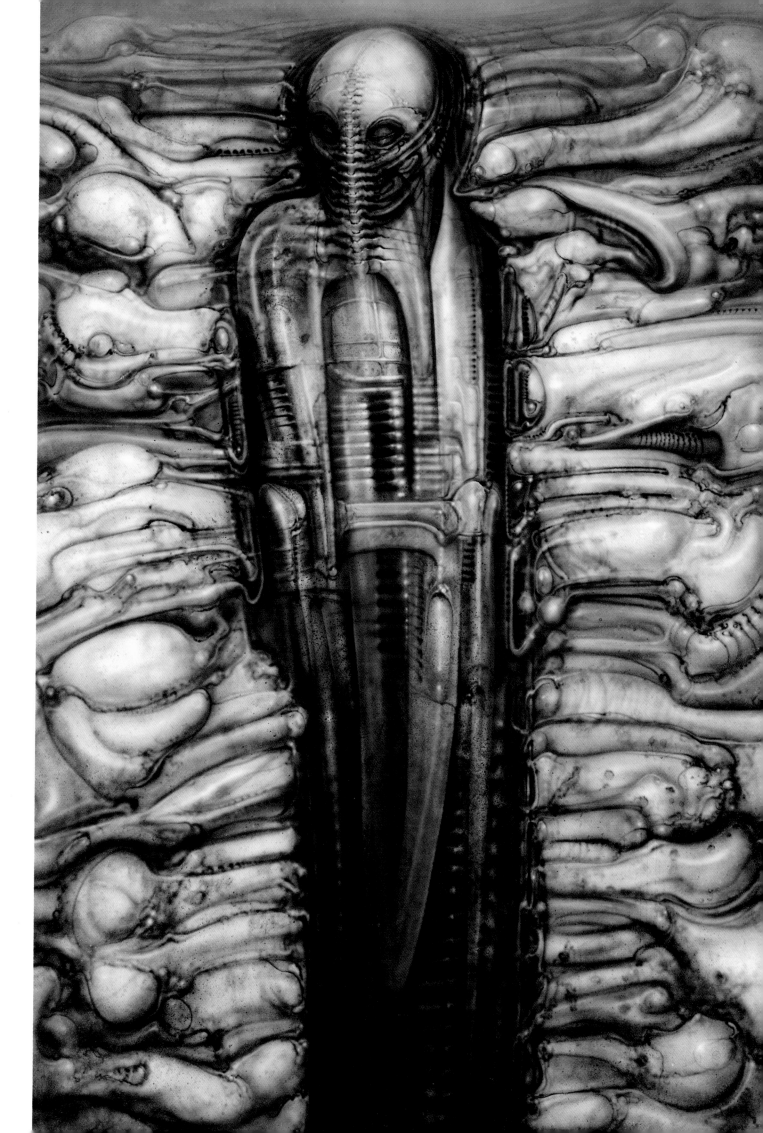

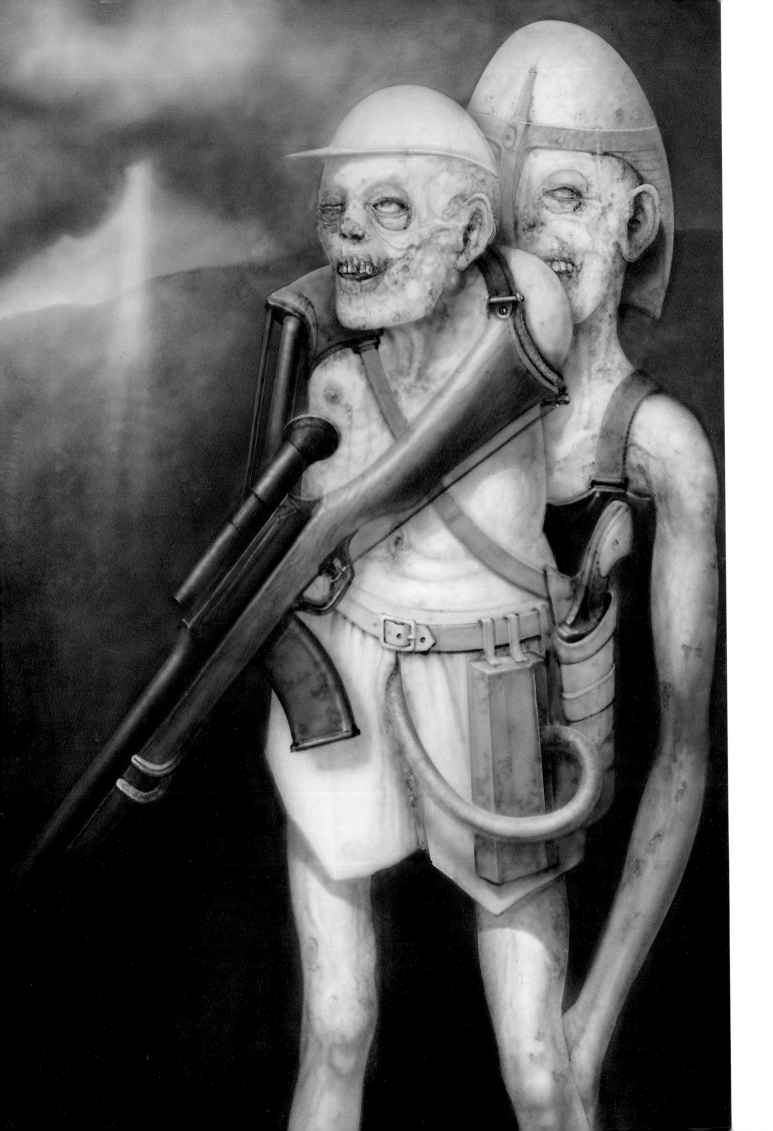

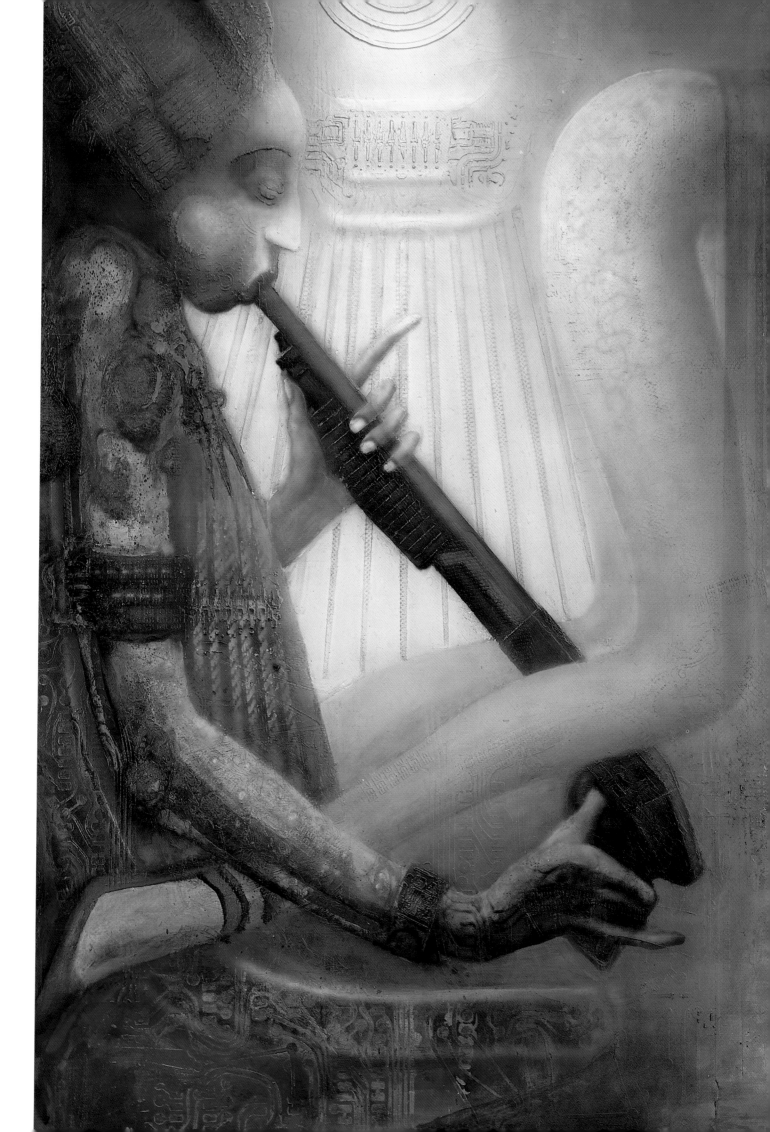

Ink sketch, 1959–60

Ghost Train II

Connections in the art world? Yes – and how. Without them artists of equal rank would be given equal treatment, and that would be unfair. Someone who is beautiful, clever, intelligent and sexy by nature should be favoured – and that's precisely what happens. In almost every profession, friendships which help you get on are not to be despised, and if you have a perfect body, a car and social manners, it's stupid to hide yourself away at home, especially when you're young. Everyone likes to see beautiful people, and they are the pride of every celebrity. They add glitter to an important vernissage. I believe it is legitimate to exploit your physical advantages. Why shouldn't people spare themselves a ten-year wait for success –

Dr. H.R. Giger in front of his pharmacy

ten years growing old and unattractive – by going to bed with someone? People with a sense of humour are also popular. Unfortunately, however, I hadn't been particularly blessed in any of these areas.

Even as a child I was eager to impress the fair sex, whether with my eccentric hobbies or by creating dream worlds which would make every beautiful wom-

Ink sketch, 1959–60

an curious. I was attracted above all to women older than myself. On the main square in Chur, where »Chilbi« was held every year, the accompanying ghost train offered all sorts of advantages for seducing women. Even as a diminutive six-year-old I helped – as best I could – put up this mysterious palace. I thus got to know a lot of the secrets of the ride before it went into operation. I also found out how the operators would leap onto the back of the cars, sometimes even stopping them altogether, in order to grope and kiss the terrified women. They would thereby feign a blown fuse, with their torches thus the only source of light. The women shrieked with fear (or something else). I knew every twist and turn of the labyrinth, with its partition walls of black cloth. Only the personnel and myself knew the secret shortcuts to the most suitable places for blocking the cars. The memory of this ghost train comes flooding back whenever I smell electricity and carbolineum. Then, too, these early erotic images float crystal-clear before my eyes.

Each year, the end of these three weeks of sensuality and the return to normal life

would send me into deep despondency. But I soon found a substitute. In the house in which my father had his pharmacy there was a wonderfully long and dark corridor, which seemed made for my own tunnel of horrors. I ran it for years with the help of a few friends. The pretty women (around my own age) all remember this ghost ride well – most of them better than I do. I was fearfully shy at the time and did not dare touch the young misses, whom I pushed through my inferno on a cart for the sum of five »rappen«.

My small, masked assistants made up for this all the more, and every ride aroused in me a sweet sensation of lust. This ghost ride was replaced by the »Black Room« (ill. p. 14), which was inspired by my reading of Gaston Leroux's *The Phantom of the Opera*.

But I was slow on the uptake, and spent my puberty assembling a crazy collection of firearms. I set up various caches of weapons in the woods. In games of Cowboys and Indians I was usually the leader and dreamed of rescuing beautiful women from the clutches of the enemy. But whenever I actually met a pretty girl I would be almost too embarrassed to speak. So I restricted myself to impressing them more or less from afar.

Ink sketch, 1959–60

▷ No. 308, *Biomechanoid*, 1976
acrylic on paper/wood, 100 × 70 cm

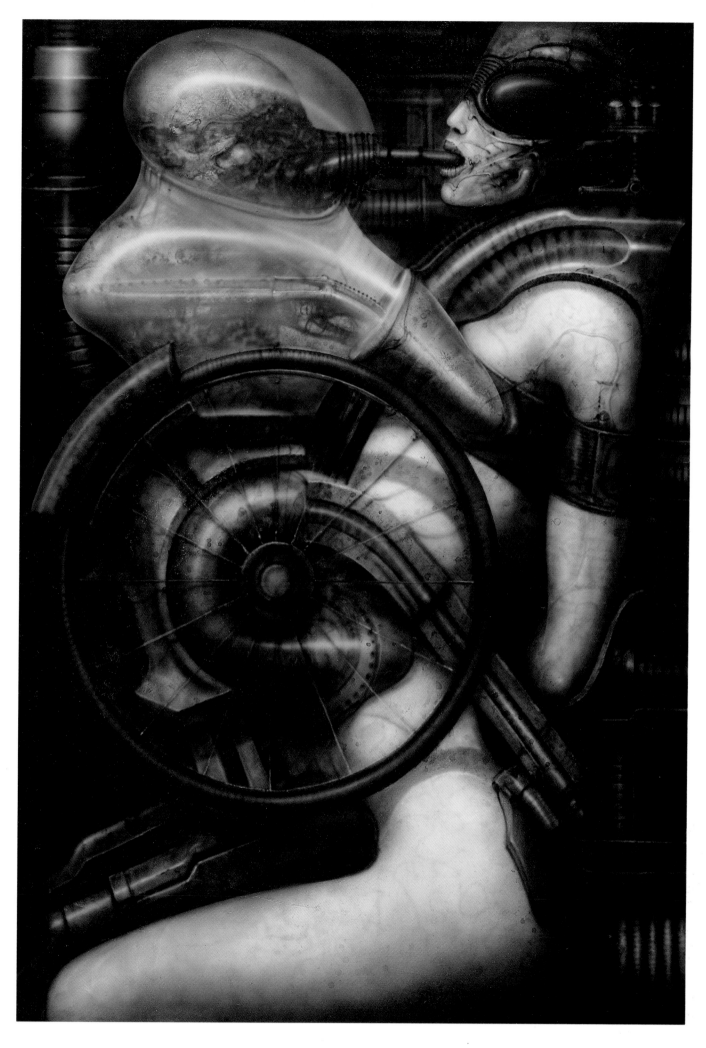

Li

I first met Li in 1966, while she was studying acting at K. Rellstab's drama studio in Zurich. She was beautiful, and remained my partner until her death in 1975. She lost interest in acting in 1974 and, with the help of Jörg Stummer, opened her own gallery. She held exhibitions of Manon, Pfeiffer and Klauke, as well as the legendary »Schuhwerke« (Shoe Works) exhibition, at which I filmed the vernissage guests while wearing two hollowed-out loaves of bread on my feet (ill. p. 91).

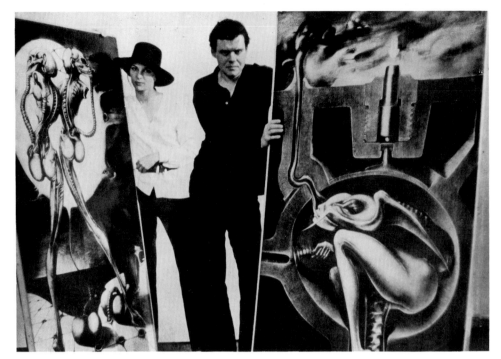

H.R.G. and Li in the Strauhof, Zurich, 1969

No. 250, *Li* I, 1974, collotype, 70 × 100 cm

▷ No. 251, *Li II*, 1974, acrylic on paper/wood, 200 × 140 cm

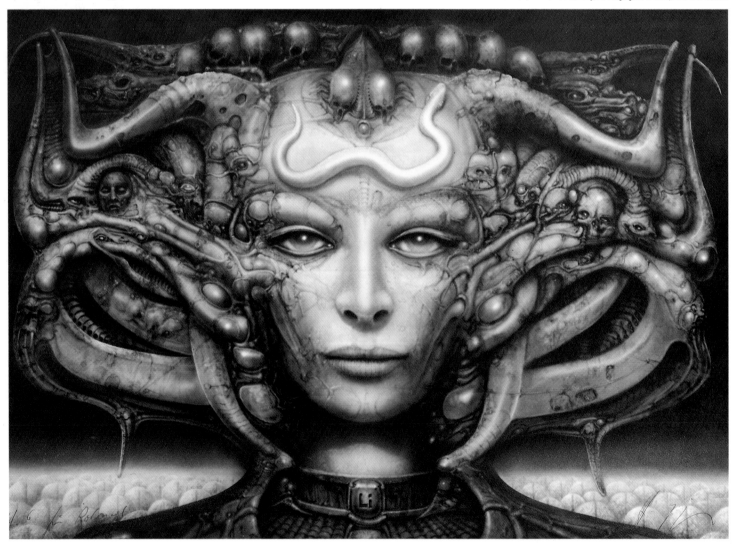

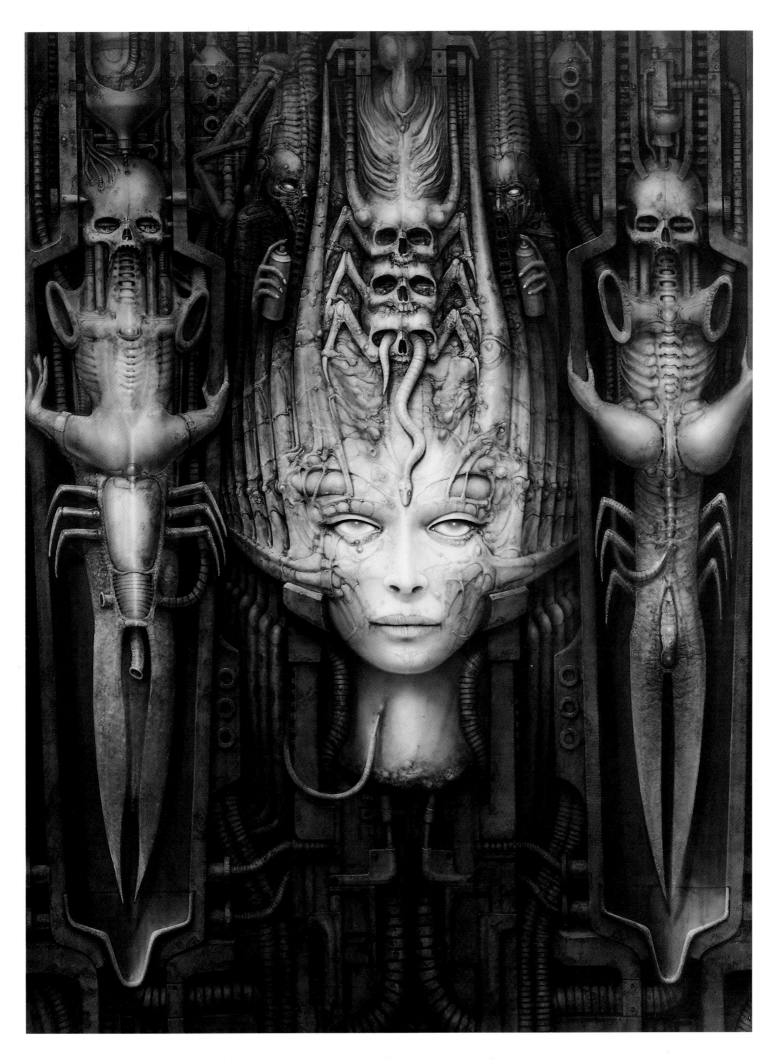

Ink sketch, 1960

carry towards the beach. These almost lifeless tubes – crumpled in several places, like used condoms – had worm-like rings tapering off at one end. They also had an orifice which gently expanded and contracted rhythmically as it extracted nourishment from the water.

As soon as I arrived on the island I decided to go for a night-time dip. My friends weren't in the mood, so I swam alone on my back in the algae-streaked shoals – utterly unaware of the presence of these revolting creatures. It was not until the next day that I realised, to my horror, that what I had taken to be algae were in fact these repulsive worms. Meanwhile, the other guests had also spotted the creatures. They stood in the shallows and stabbed at them with short sticks and disgusted faces. I could see nothing but worms. Lunch was vegetable soup. Before anyone else had started, I picked up my spoon and discreetly, with a nauseated expression, probed the broth.

My neighbours didn't even touch the soup. I achieved an overwhelming success; the soup was not only left uneaten

in the dining room but was untouched by the whole club. I had single-handedly spoilt the meal for everyone. The result was all the more drinking – and swimming only in the pool.

Ink sketch, 1989

Collecting Trouser-Brace Fasteners

Another of my passions was for collecting trouser-brace fasteners, something subconsciously connected to my loathing for worms and snakes. Trousers were held up at the back by two buttons in the middle and, at the front, by two buttons on the left and right of the stomach. The objects of my obsession were the silk-bound rubber loops, available in all colours and sizes, which fastened the brace-straps to the trousers. For me, however, they had to be damaged. Most exciting of all were the ones where the silk covering had already worn through, leaving the trousers hanging by just one or two rubber strands – in other words, just about to snap, which would mean the trousers fell down. I myself had to wear leather, tear-resistant types which left me cold. I bartered for these semi-perished straps with my poorer fellow students by buying them new ones. The items in my collection had a certain similarity with squashed worms, slowworms and snakes attempting, half-dead and without success, to drag their flattened bodies to safety. I later had a horrible experience with worms on Mauritius. There the local nightmare was the transparent sea-worms, five feet long and with a diameter of about two inches, which the sea would

Child's drawing (trouser braces) ▷ No. 275, *Chidher Grün*, 1975, acrylic on paper/wood, 200 × 140 cm

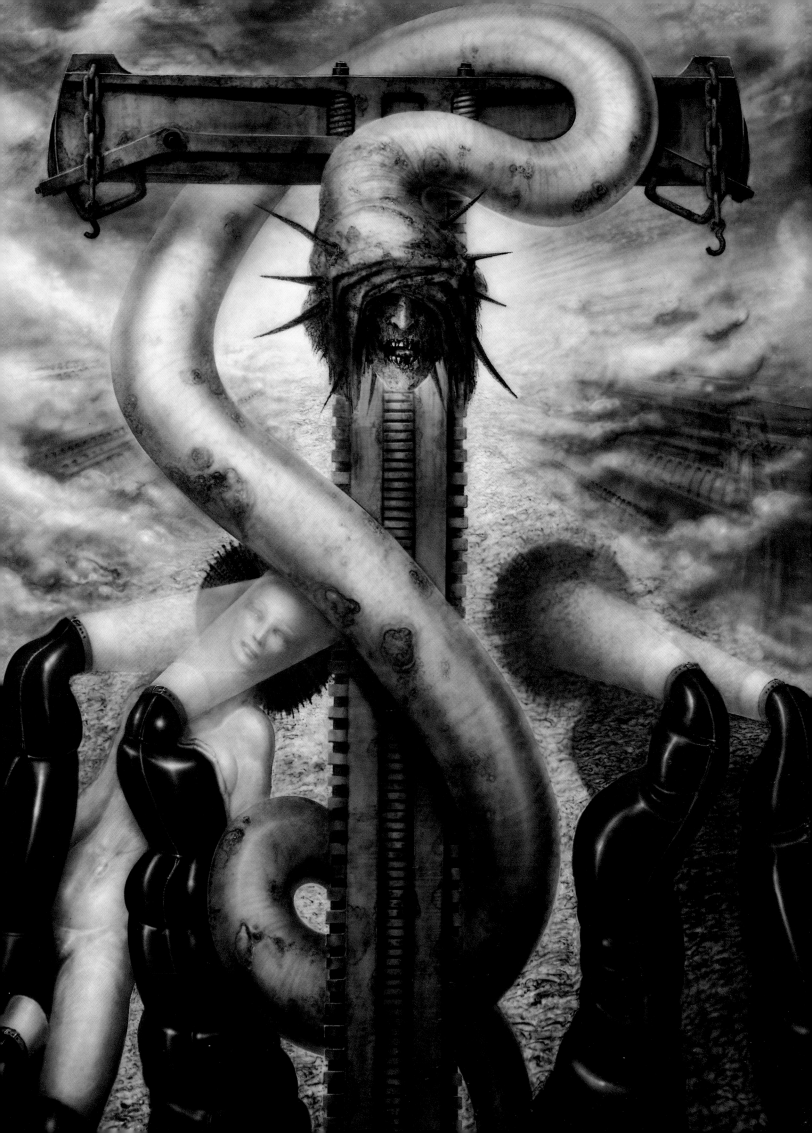

Shafts

The »Shaft« pictures, which I began to produce around 1966, have their origin in my dreams. I was sleeping badly at the time and was pursued by nightmares.

In the stairwell of my parents' house in Chur was a secret window, which gave onto the interior of the Three Kings Hotel next door, and was always covered with a dingy brown curtain. In my dreams, or nightly wanderings, this window was open and I saw gigantic, bottomless shafts, bathed in a pale yellow light. On the walls, steep and treacherous wooden stairways without bannisters led down into the yawning abyss. Since I have taken to drawing these imaginary chasms, the window of my dreams has remained

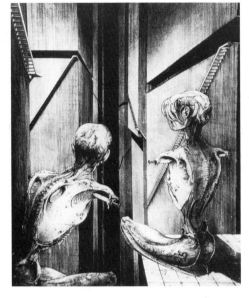

firmly and definitely shut, but another source of my fantasies was our cellar. Approached via an old and musty spiral stone staircase, it led into a vaulted corridor. As our neighbour, the hotel proprietor, told me, there were two subterranean passages in Chur which led from the bishop's palace down through the Rebberg and beneath the town. Part of one of these passages formed our cellar. The exit from the cellar of the hotel on the Reichsgasse had previously been open, and anyone who dared could descend for quite a way. Some time previously, however, it had been walled up, as there was danger of subsidence. I saw only the locked door, which inspired in me the most sinister imaginings. In my dreams, however, these passages were open and led into a monstrous labyrinth, where all kinds of dangers lay in wait for me. Almost every dream led me down the winding staircase into this magic world of the imagination, both attracting and intimidating me at the same time.

Top left: No. 62, *Shaft No. 6*, 1966,
 ink/paper, 80 x 63 cm
Top right: No. 26, *Shaft No. 3*, 1964,
 ink/paper, 21 × 15 cm
Left: Cellar stairs at 17 Storchengasse, Chur
Centre left: No. 43, *Shaft No. 5*, 1965,
 ink/paper, 30 × 21 cm
Centre right: No. 42, *Shaft No 4, The Power and
 Weakness of Organization*, 1964,
 ink/paper, 30 × 21 cm

Bottom left: No. 39, *Shaft No 3*, 1965,
 ink/paper, 30 × 21 cm
Bottom right: No. 38, *His Master's Voice*, 1964,
 ink/paper, 30 × 21 cm

▷ No. 63, *Shaft No. 7*, 1966
ink/paper, 80 × 63 cm

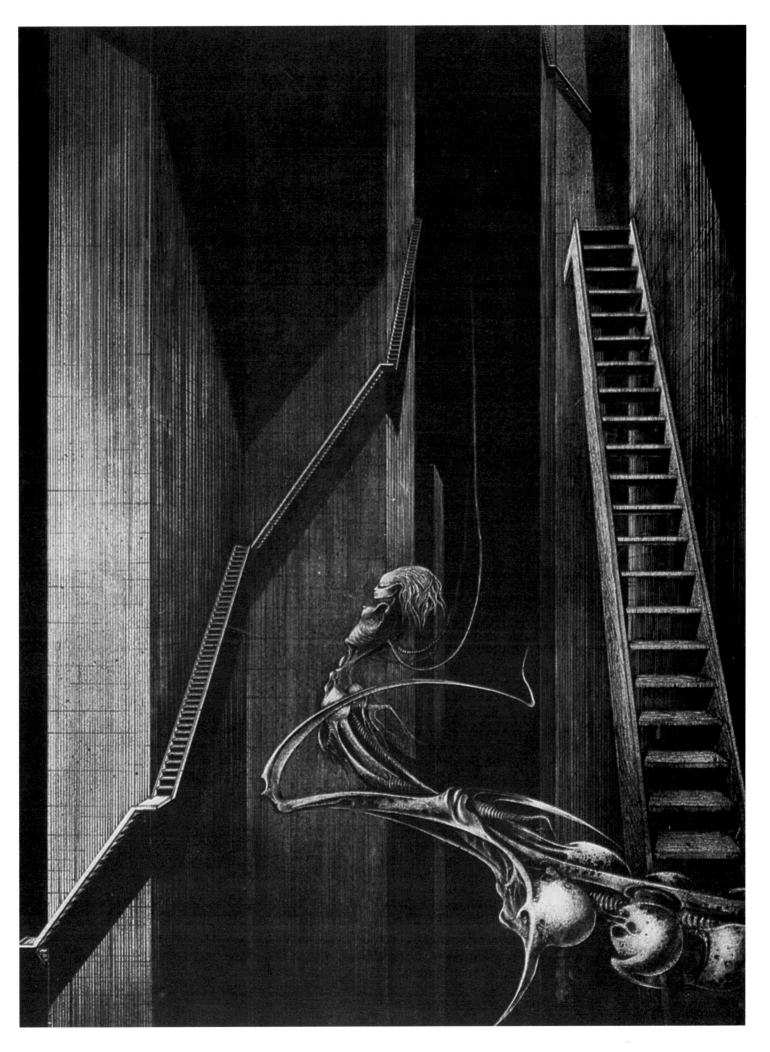

Sketch, 1961

I tried to stay awake for as long as I could. I dreaded falling asleep, because I was certain to dream about them. Not long afterwards I saw documentary films of atrocities carried out in the concentration camps. These forced the Chinese photos somewhat into the background. But my Angst had significantly increased. The first impaled figure to fascinate me as a child was a living scarecrow in a local fairytale, which I made my mother read me again and again. I think this stake-bound life, for whom redemption meant as soon a death as possible, plainly showed me the senselessness of existence. An existence better never begun. Many of my works reflect this state of hopeless enslavement which leaves no room for religious beliefs. My childhood memories of the civic museum in Chur also belong within this context. There Egyptian mummies were exhibited along with amputated hands and feet.

These impressions were strongly reinforced by Jean Cocteau's film *La belle et la bête*, in which arms come out of the walls and hold candelabra.

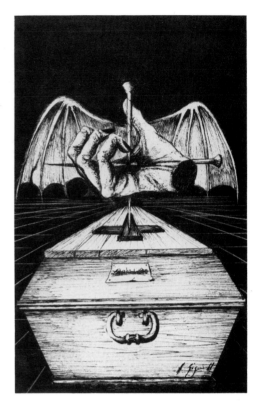

Ink drawing, 1961

Chinese Torture

One of my most vivid memories stems from my days at the Zurich School of Applied Arts. A fellow student showed me some photographs in a book which I would rather never have seen. People, seeing my pictures, often think I must take pleasure in extreme cruelty. Up till then I had only seen horror films in which wooden stakes were driven through the hearts of corpses, and that only acted.

What my friend showed me, however, was considerably stronger stuff. It was a series of photos from 1904 showing the torture of the Emperor of China's murderer.

The victim was skewered on a stake, and the mob which surrounded him were slowly cutting off all his limbs. I shall never forget the face of the impaled victim, convulsed in agony, nor the cruel grins of the spectators. These photos, which so gripped the French author Georges Bataille that he was never to get away from them, shocked me as nothing ever before. My friend was delighted to have shown me something which affected me so profoundly.

Unnerved, with the hideous sequence of images still before my eyes, I went to my room. My friend had indeed succeeded in impressing me so much that I was afraid to be alone. For a whole week

Press cutting from the daily newspaper »Blick«:

Seriously Injured by Milking Stool

Schöftland. – The Advisory Board for the Prevention of Agricultural Accidents in Schöftland reports of a case in which a farmer has been seriously injured by a milking stool. The farmer was milking his cows when the leg of the stool suddenly pierced the seat and impaled the farmer, causing severe buttock injuries.

Injuries of this kind may have serious consequences, warns the Advisory Board. Investigations have revealed that, prior to the accident, the leg had become detached from its mounting and was able to press directly onto the seat and hence to penetrate it when subjected to weight. The normal ageing suffered by the plastic seat had also facilitated the rupture. Although such accidents are very rare, the Advisory Board and manufacturing company have now jointly developed a supplement which is intended to prevent the seat piercing in this way.

Vlad the Impaler

Vlad the Impaler was a cruel, particularly blood-thirsty ruler; he lived in Siebenbürgen and was also called Count Dracula. He liked to breakfast amidst the heads of his enemies, stuck on wooden posts. Legend turned him into a vampire who at night, as a bat, sucked the blood from the tenderly outstretched necks of his victims – usually beautiful virgins. Besides *Nosferatu*, Andy Warhol's *Dracula* is far and away the best film on Dracula. In this the Count is a blood junkie who rushes onto the street whenever there is a road accident, in order to at least be able to dunk a piece of bread in the blood.

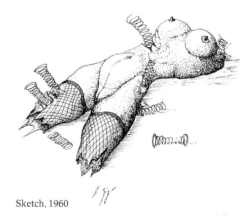

Sketch, 1960

▷ No. 412, *Vlad Tepes*, 1978
acrylic on paper/wood, 200 × 140 cm

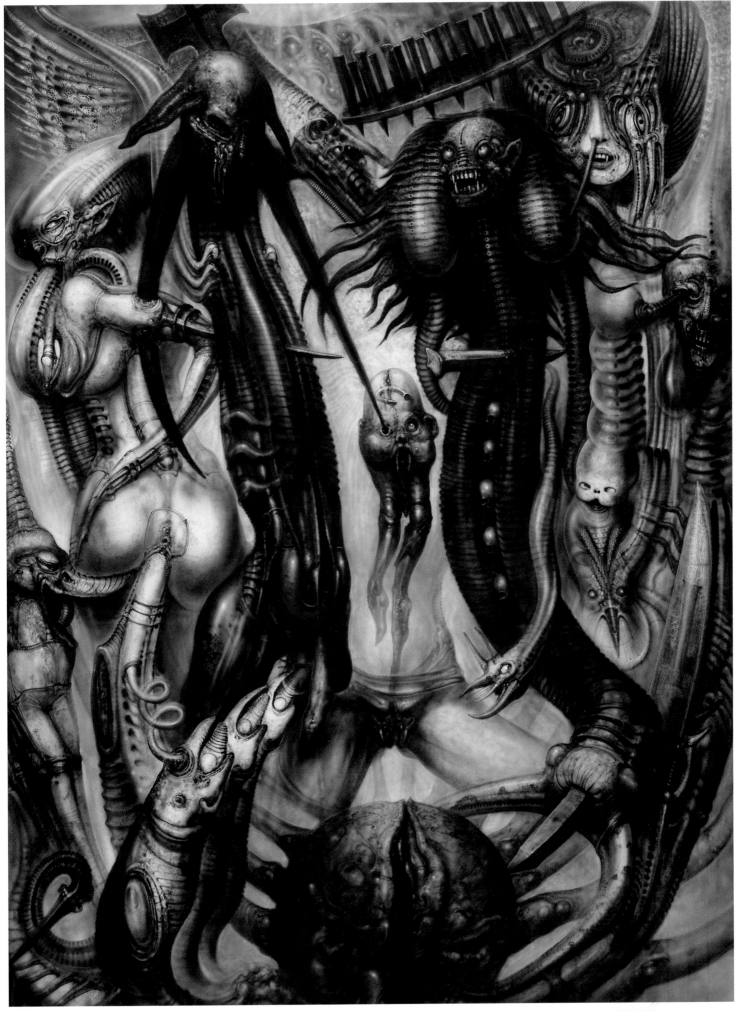

Friedrich Kuhn, 1972, one month before his death
Photo: H.R.G.

Friedrich Kuhn

Born 1926 in Gretzenbach, died 1972 in Zurich, Switzerland. A full-blooded painter, a walking provocation, who unfortunately died far too early. His enormous significance for the development of Swiss art has sadly not yet been recognized.

I first met him three years before his death. At that time I was ignorant of what alcoholism really meant, and found it somewhat amusing, without properly understanding the anguish and desperation of the afflicted. Kuhn was a so-called full-blooded painter, a forerunner of the »Junge Wilde« (Young Savages). His early work reflected late Picasso. Everything he laid his hands on became art. He was also a master of the art of living and played the *grand seigneur*. Furthermore, he was smart. He sometimes acted his drunkenness in order to tell people to their faces exactly what he thought of them. In my picture, *Hommage à Friedrich*, I portrayed him as a Magus. He only had a few collectors, but they stuck to him. The rest dismissed his work as infan-

tile daubing. Kuhn was aware of his own quality and despaired that people would only take him seriously when it was too late. His rival in those days was Alex Sadkowsky, who would often greet me with the words »Hey, Giger, why don't you just get on and kill yourself?« Not something which entirely convinced me of the quality of his person. Kuhn was quite different. We valued and respected each other. He was also almost the only person ever to invite me to barter with works instead of money. Kuhn was a real character in the Zurich scene. I could fill a book with stories about him – some of which I've witnessed myself.

Friedrich also liked my girlfriend and was constantly proposing he should have her in exchange for pictures. But she apparently didn't think enough of his works. She often played chauffeur for his '55 Jaguar since he himself had no driving licence. Finally, a year before his death, he married someone else. I was a witness and sat through the most miserable of wedding receptions – no alcohol. That may have been a condition of the bride. His mother was not allowed to know of his marriage. He had to slip out of the house unnoticed, and we were very concerned he wouldn't show up for the ceremony on time. He had already failed to appear at two earlier weddings.

In the course of time the proportion of wine in his tea increased and he grew more human. In the end he left out the tea altogether, and let Eddie Meier chauffeur him around in a London taxi on three-day drinking tours. His persecution complex took over. In confused nighttime telephone calls he kept me up to date with reports on his person. In public he again became loud and tiresome. He was a walking provocation. A fire-fighting team from Egg, into whose clutches he fell, tied his feet with a rope and dragged him round in circles in front of the restaurant, some of the men hitting the defenceless victim with sticks and bars. They may have thought he was dead, for he was found next morning beside a half-dug grave. Soon afterwards, on a nighttime joy-ride with his wife in an open-top car, he drove into a restaurant driveway which stupidly lay right on a bend. They got jammed. Half in the restaurant and the rest in the garden. A crack above the entrance and up to the gable divided the house in two. The owner, awakening dazedly from sleep, assumed he'd just survived an earthquake; upon Kuhn's ordering two Irish coffees for himself and his wife in the trapped car, he fell into

such a rage that Friedrich – cowardly and without his wife – made his escape on a stolen bicycle. Next morning – I think it was Whit Sunday –, he rang and asked me to help him find his car. We set off that evening. First we visited the scene of the crime, where the entrance had now been boarded up. Friedrich cowered nervously in the darkness of my car, and I didn't dare ask the owner what had happened to the offending vehicle. So we wandered through the darkened village on our search. In vain. Friedrich was planning to doctor the brakes so that he wouldn't have to confess to the court that he hadn't been in control of the car.

He never went to court. His liver gave out, and the funeral turned into a festival. Each of his girlfriends wanted to be the most upset, and everyone got drunk in the upper Flühgasse. Afterwards my girlfriend drove me home and, in a sort of final farewell to Friedrich, threw up out of the moving car.

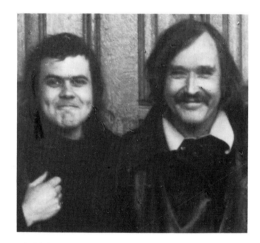

Friedrich Kuhn and H.R. Giger
Photo: B. Bühler

▷ No. 221, *Friedrich Kuhn II*, 1973
collotype, 105 × 78 cm

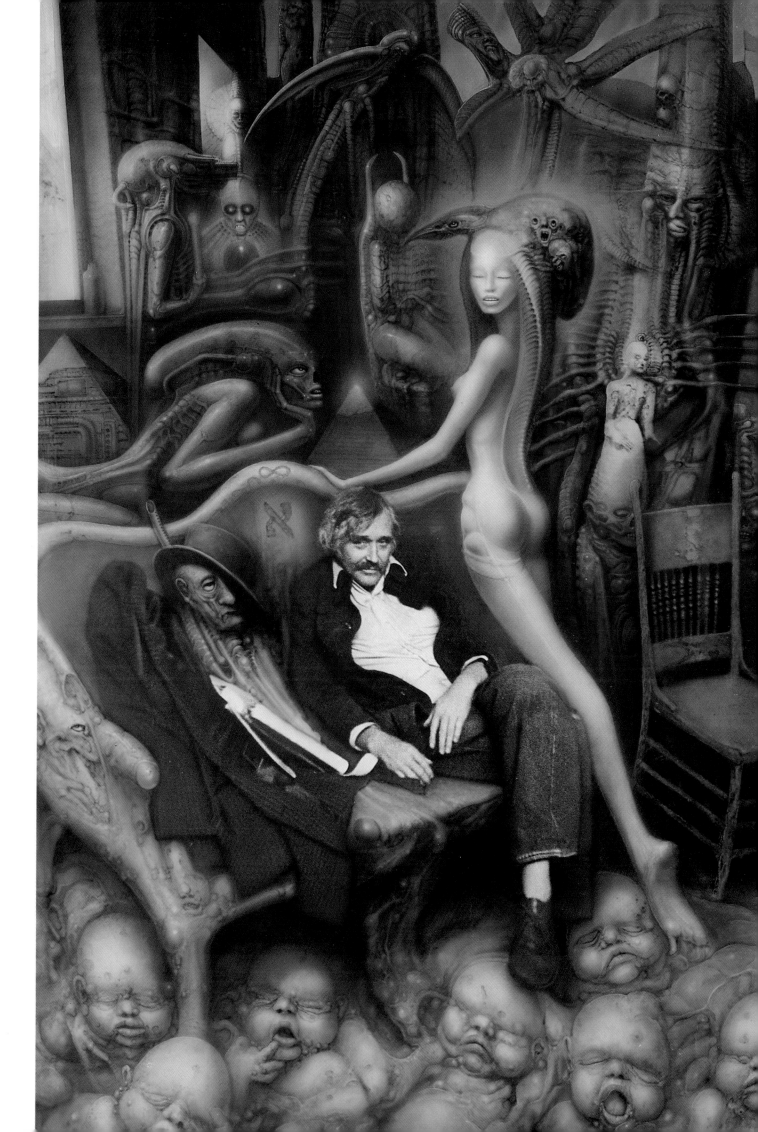

»The Necronomicon«, title page

H.P. Lovecraft

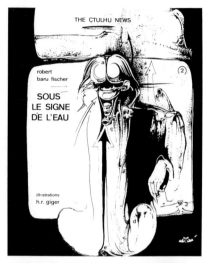

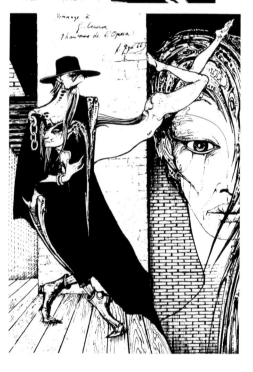

Lovecraft and the Necronomicon

As far as I can remember, the first time I heard of the Cthulhu myth and the Necronomicon was when the Zurich writer Robert B. Fischer published a journal called *Cthulhu News*. I illustrated the stories for the second issue. These drawings are all reproduced in *Giger's Biomechanics*. I slowly began to develop an interest in the originator of the myth and subsequently came across an early SF writer who lived in Providence, New England (USA). Through his father, a member of the Egyptian lodge of freemasons, he possessed an extensive esoteric library. It may be assumed that he owned fragments of the Necronomicon, which means »names« or »masks of the dead«, since it appears in almost all his horror stories as a book of magic which would bring dreadful misfortune to mankind should it fall into the wrong hands. It includes the legend of the great gods with almost unpronounceable names, such as *Cthulhu* and *Yog-Sothoth*, who slumber in the depths of the earth and oceans and who will arise at a certain time – when the stars are right – to seize world dominion. Thus it is written in the NECRONOMICON written by the mad Abdul Alhazred. A book full of magic spells and pictures of the terrifying monster gods who will threaten us. These monsters are described by J.P. Lovecraft in stories such as *The Call of Cthulhu* and *The Case of Dexter Ward*. The best biography of Lovecraft was written by L. Sprague de Camp.

In the days of Elizabeth I., court astrologer John Dee and his mediumistically-inclined assistant Eduard Kelly went to Prague, in order to attempt to change lead into gold at the court of King Rudolph. During this period, Kelly received details of the original Necronomicon in runes and texts in Enochian (the language of the angels) from the Angel of the West Window. No illustrations of the monstrous gods have been found. Fragments of this NECRONOMICON (Al Azif) survive today, some of them in the British Museum in London.

Gustav Meyrink wrote a gripping story on John Dee and Eduard Kelly, based partly on fact, in one of his best books, *Der Engel vom westlichen Fenster*

While I was looking for a title for my gloomy pictures, Sergius Golowin, my spiritual father and the well-known Swiss researcher of myths, drew my attention to Lovecraft and – since the original book is only preserved in fragments –, suggested the name *Giger's Necronomicon*. This title sewed not a little confusion, since Lovecraft followers thought they had at last found their Necronomicon.

Thirteen years have since passed and many Necronomicons have appeared showing fragments of magical rituals; none contain pictures of extraterrestrial monsters, however. My books thus gradually became known among insiders and, without my knowing, I was made a member of a lodge as Frater Alien.

From top to bottom:
Sous le signe de l'eau, 1968, »The Cthulhu«, transcop, 21 × 24 cm
After the 120 Days of Sodom, 1968 transcop, 21 × 24 cm
Phantom of the Opera, 1968 transcop, 21 × 24 cm

▷ No. 311, title page of *Giger's Necronomicon*, 1976 acrylic on paper/wood, 100 × 70 cm

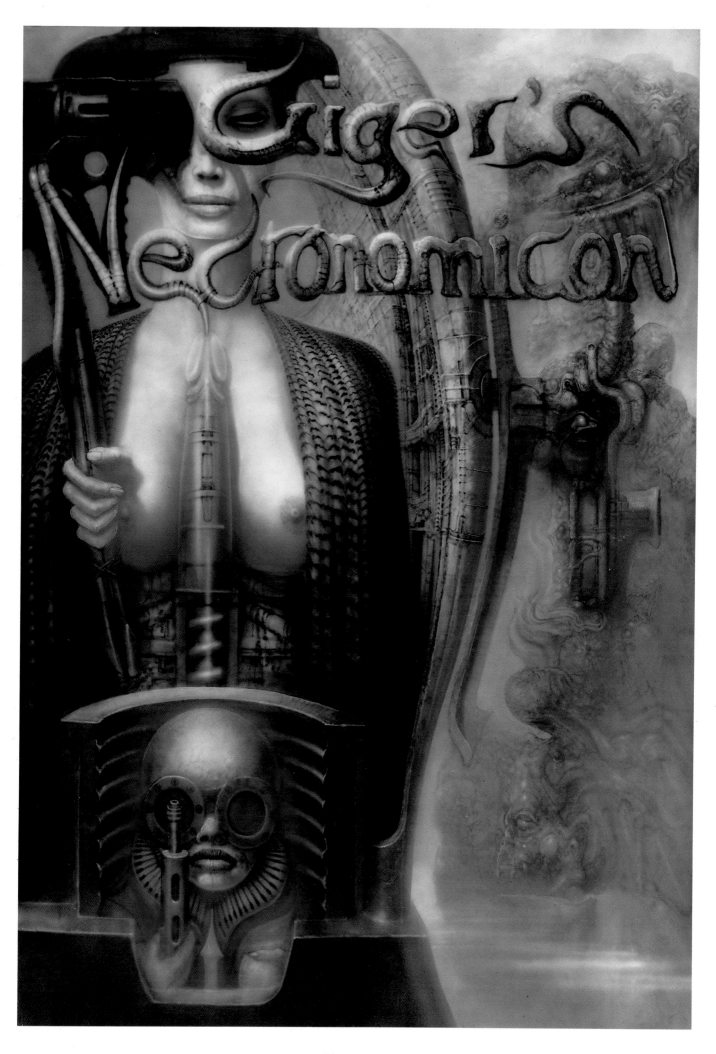

Art Magazin

In 1986 I visited a gallery called *Art Magazin* for the first time. It was located between two small prostitution establishments in the Brauerstrasse. The owner had fixed a light fitting in his hair with brilliantine and I liked him immediately. It was a meeting-place for way-out types and first-time exhibitors. Also attached to the gallery was the Museum of the Soul, run by Pier Geering, artist and Rolf Mueller's partner. I began participating regularly in thematic exhibitions, in particular in the »Fête des morts« which took place every 1 November. In 1988 I prepared a one-man show for *Art Magazin* entitled »Expanded Drawings«. The exhibition was very successful, since I had set my prices to suit the young customers. In October came *Art Magazin 2*. The events are becoming increasingly multi-medial, thanks to Pier Geering, who knows and manages a large number of bands. He himself wrote a comic-strip story entitled *Robofok*, which I illustrated – something I'd wanted to do for years – and there is now at last a gallery exhibiting comic strips.

Stamp *Fête des Morts*

Stamp *Museum of the Soul*

P. 43: *ROBOFOK* comic strip
(Text: Pier Geering), 1989

Right and below:
Battery Farming

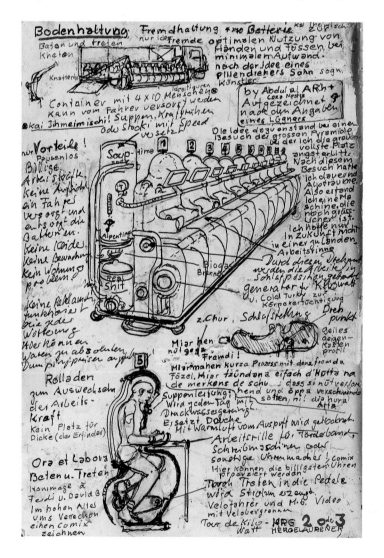

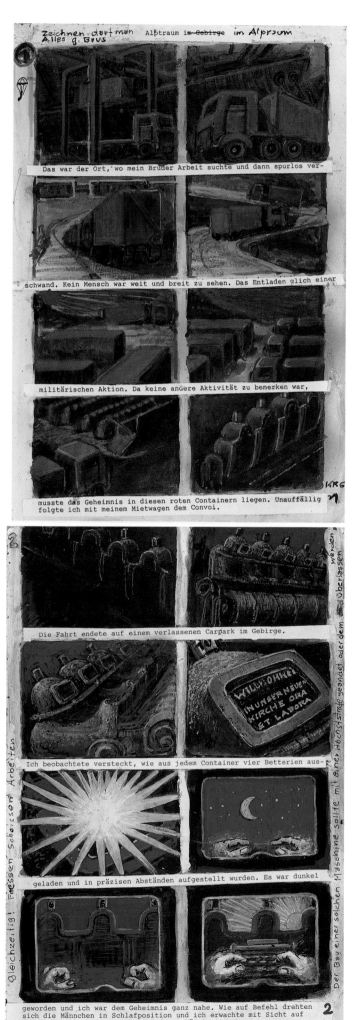

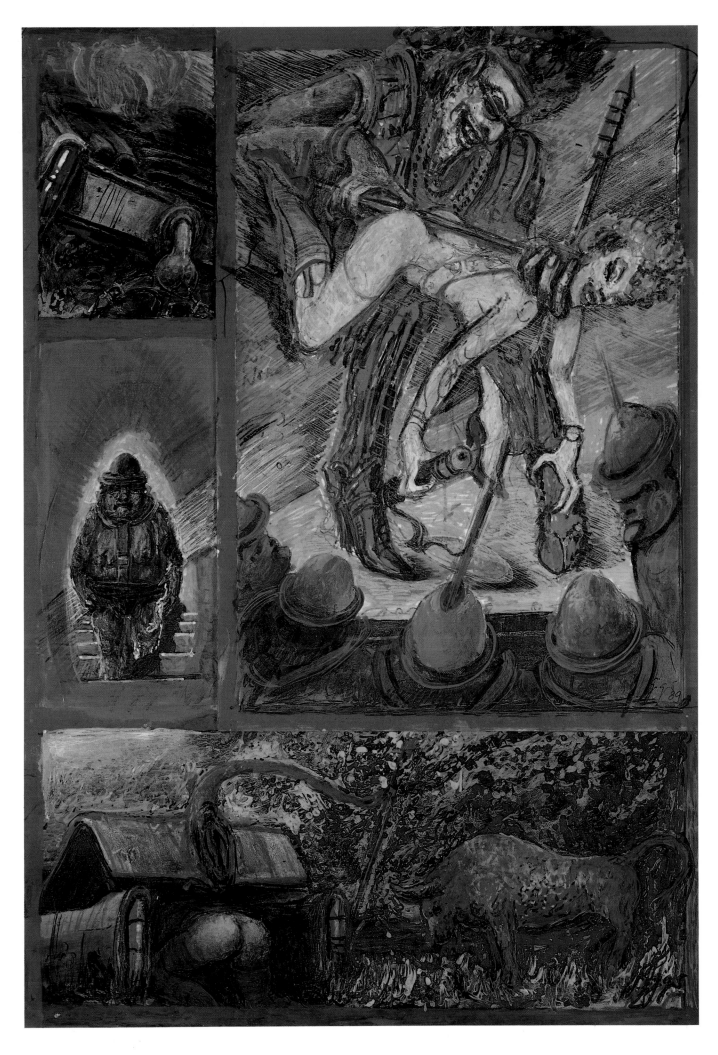

43

On the Spray-Gun, or Airbrush

There are still painters and other experts who maintain that an airbrush cannot produce art. As if a paintbrush guarantees quality. I believe you have only truly mastered the airbrush – which I personally find the most direct medium – when the technique is no longer visible in the picture. Crude spraying with stencils, fantasy car-body art and commercial advertising have caused the technique – which actually dates as far back as Man Ray – to suffer.

Over the course of time you get so used to handling the airbrush that the process becomes automatic, like steering a car. You yourself become an automaton who can still function even at the frontiers of clear thinking, such as when under the influence of drugs, for example.

The Dutch customs once thought my pictures were photos. Where on earth did they think I could have photographed my subjects? In Hell, perhaps? Only after getting an expert to come in specially and certify that my works were indeed airbrushed would they let the pictures through.

Collage of human head with airbrush eye

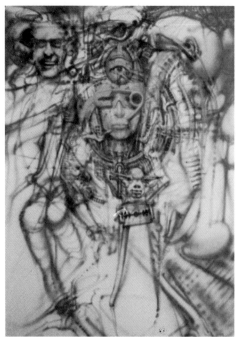

H.R.G. in St. Abandio

▷ No. 302a, *Necronom IIIa*, 1976
acrylic on paper/wood, 100 × 70 cm

Illuminatus I sequence, 1978
acrylic on paper, 100 × 70 cm

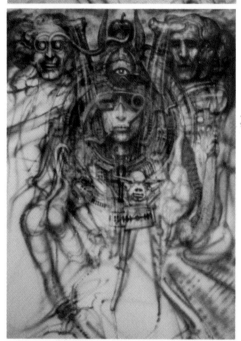

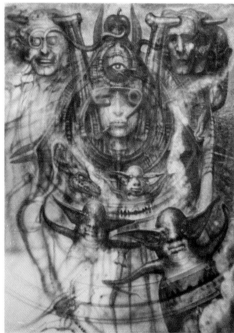

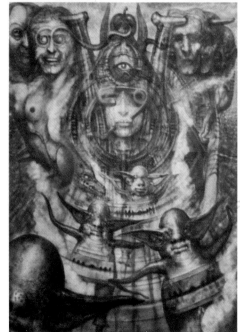

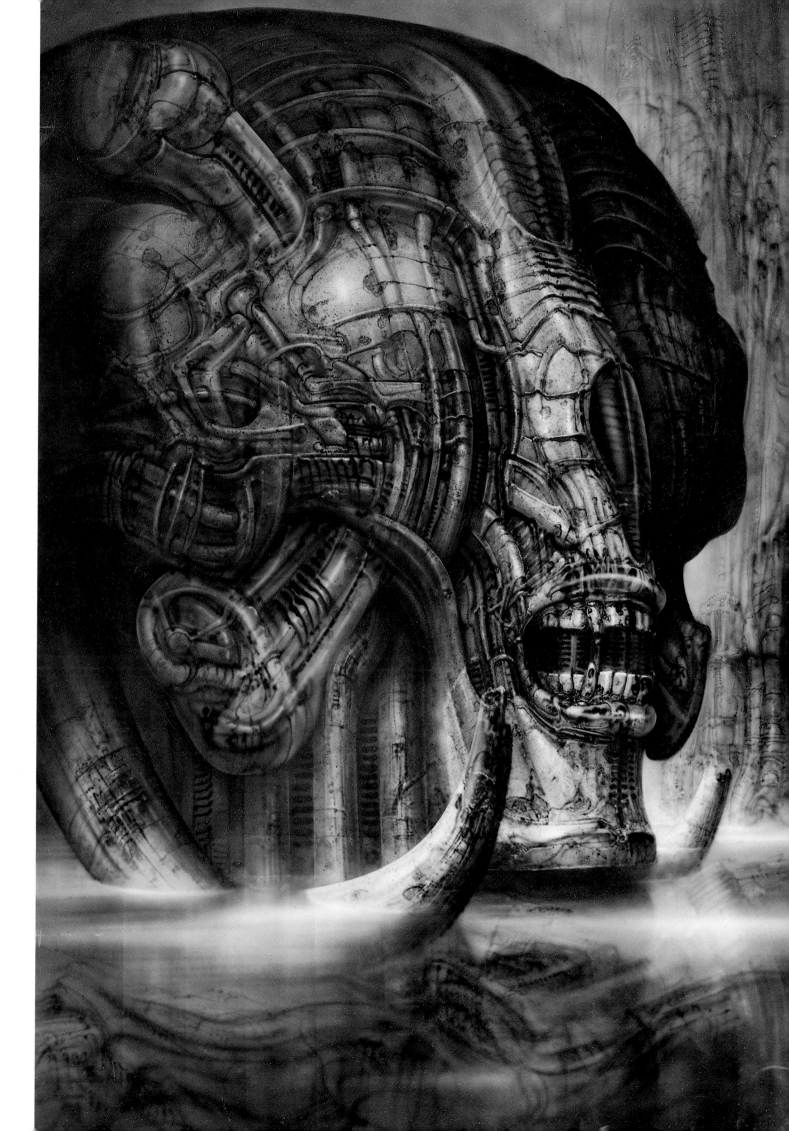

House in Poiana

Li Tobler with *Voice of America* figures, 1968
polyester, 85 × 75 × 20 cm

First Sculptural Works in Tessin

In the summers of 1966–69, on the small terrace above the wine cellar in Poiana, Tessin, on Lake Lugano, I produced – in addition to my ink drawings – sculptures such as *Bettler* (Beggar), *Leben erhalten* (Preserve Life) (ill. p. 47) and my first »E.T.« for F. M. Murer's film *Swiss-made*. A bank had donated him a bit of money on the occasion of some anniversary, and Murer was thus able to offer a modest fee for my polyester shell and the polyester shell of a dog (ill. p. 47). The damp studio gave me permanent rheumatism. My sister and brother-in-law were then living in the main house, with its lake-side terrace above the road. I often swam hourly in Lake Lugano in order to relieve my backache and rinse off the polyester glass dust.

H.R.G. at work

No. 106, *Biomechanoid*, 1969
polyester, wood, metal, 100 × 120 × 52 cm

Figure: *Biomechanoid* (rear)

Figure: *Biomechanoid* (front)

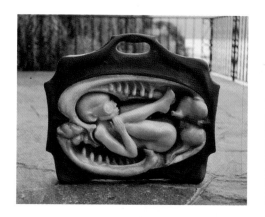

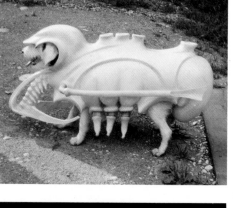

Top left: No. 77, *Suitcase Baby*, 1967
 polyester, 20 × 50 × 75 cm
Top right: Shell of a dog from the film *Swiss-Made* by
 F. M. Murer, 1967–68, polyester
Bottom left: upper object: No. 89, *Preserve Life*, 1966
 polyester and wood, 150 × 135 × 15 cm
 lower object: *Beggar* (Biomechanoid),
 1967, bronze, 58 × 58 × 75 cm

From top to bottom:
H.R.G. during filming
Object for the film: *Home Killer*
(The Blood-Glass), 1967

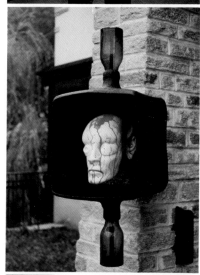

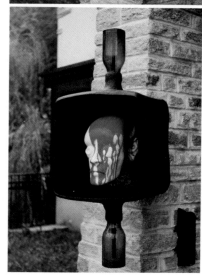

Sketches

Biomechanoids

In an age in which the classic words of the Surrealists – »As beautiful as the unexpected meeting, on a dissecting table, of a sewing machine and an umbrella« – can become reality and are perfectly achievable with an atom bomb, so too has there been a surge of interest in biomechanoids. 1968 saw the publication of my *Biomechanoids* screen-print portfolio (published by Bruno Bischofsberger, Zurich). These I understood as a harmonious fusion of technology, mechanics and creature. Gene research will yet teach us fear. Cloning (the production of two identical organisms) is already a nightmare. Siamese twins as workers, one lower body, two heads, four arms. With all the advances of recent times it will no doubt soon be possible to clone soldiers and policemen in the form of my *Beggar*, i.e. a hand with arm which, in the middle of the upper arm, passes into the top part of the lower leg with foot. The central sections of these primitive arm-and-leg monsters are equipped with sensors and all the other technical innards that a remote-controlled robot needs. I developed the 3-section design in the 1963 drawing *Atomfreak*, in the 1968 bronze sculpture *Beggar* and, with stripes and pistols, in *USA-Couple*. In 1989 I used the theme for illustrations for P. Geering's *Robofok*.

Top: Filming *Swiss-Made*
Centre: Filming *Swiss-Made*
Bottom: Filming *Swiss-Made*

P. 50: No. 255, *Biomechanoid III*, 1974
acrylic on paper, 134 × 103 cm

P. 51: No. 312, *Biomechanoid Landscape*, 1976
acrylic on paper, 200 × 140 cm

Delphine (now an actress in Paris) with *Biomechanoid*, Zurich, 1970, (photographer unknown)

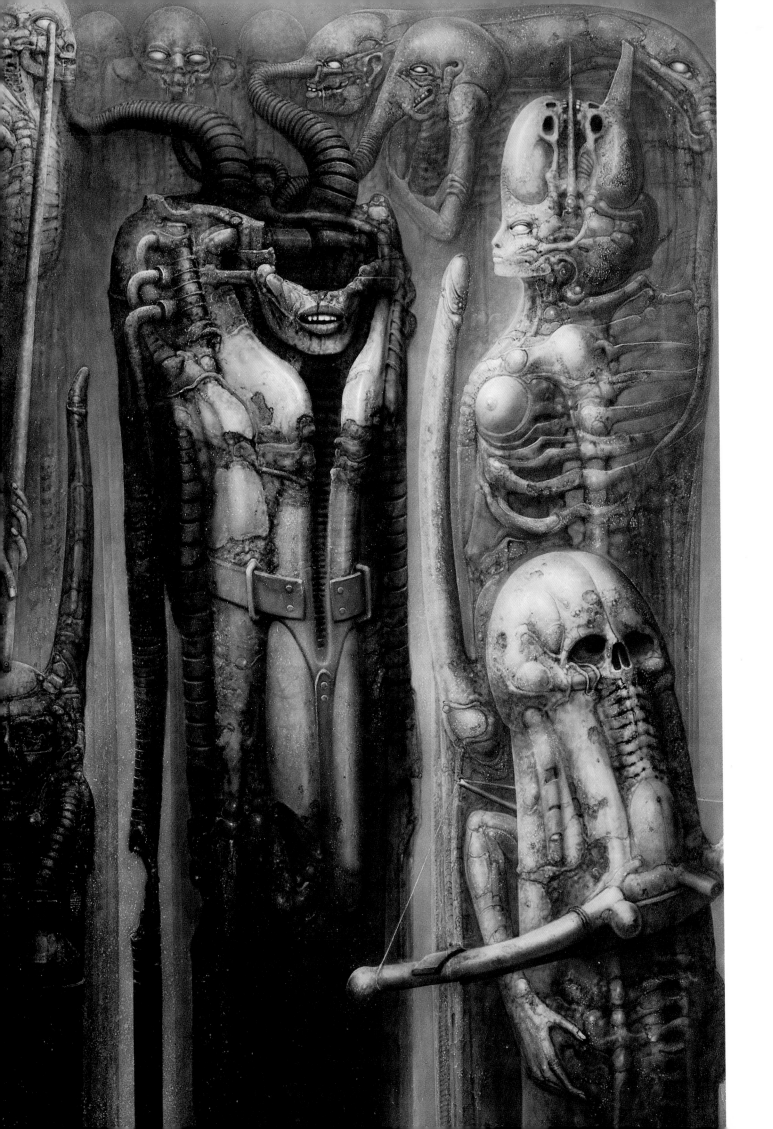

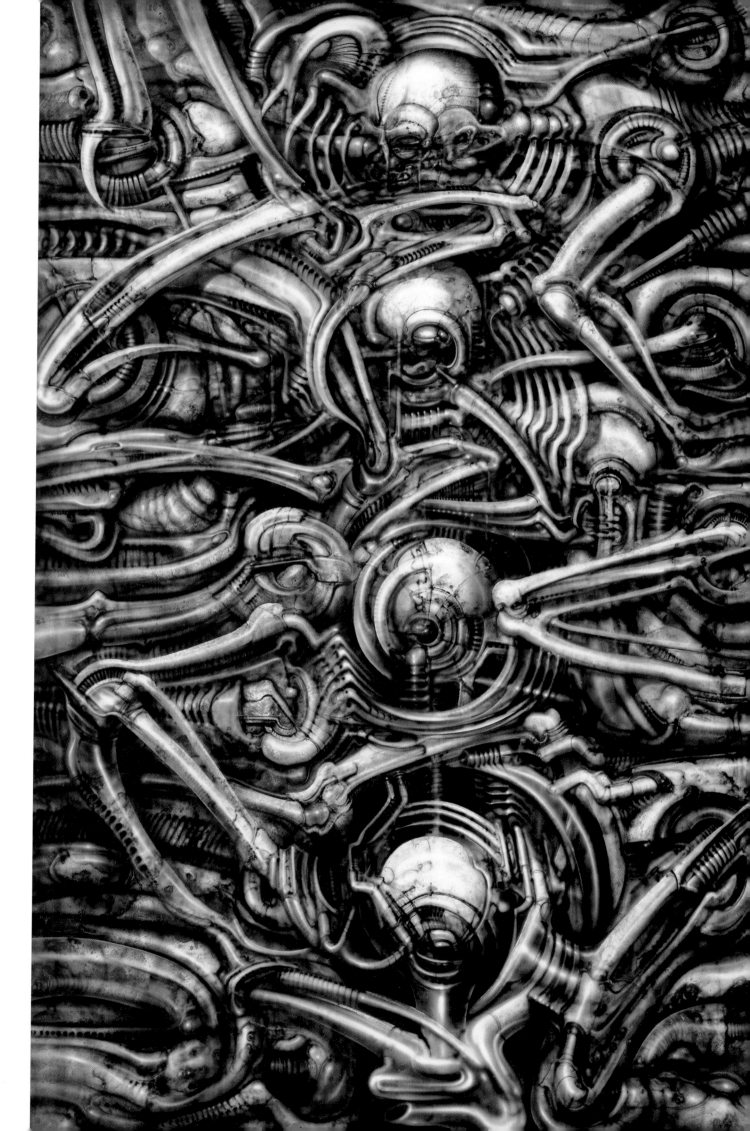

Dune

I first heard about *Dune* through Bob Venosa, an American painter of fantastic realism who lived in Cadaqués with his family and was a frequent visitor at Salvador Dalí's house. It was a project for a three-hour 70 mm science fiction film, in which Dalí was to play a leading role for a fee of $ 100,000 an hour (he was later invited to leave the film because of his pro-Franco statements). Bob Venosa telephoned me to say that the director Alexandro Jodorowsky, to whom Dalí had shown my catalogues, was interested in my work. So I went to Spain, but unfortunately Jodorowsky had already left.

Dalí, however, showed a polite interest in my work and introduced his wife Gala, describing her as a specialist in monsters and nightmares whose external appearance completely belied her inner world. Gala then expressed the opinion that I would only need to wear a mask in order to completely match the world of my pictures, and this led her into an hour-long diatribe against the evils of the world, of which she had had years of experience. She was really one of the most impressive ladies I have ever met.

I returned home, stupidly leaving my current girl friend in Cadaqués, where Dalí used her as a model and tried to couple her with a young hippie. He wanted to celebrate the ceremony himself and supervise the accompanying rituals, in his own special way. I was secretly amused by the whole affair, as I had just read »The Magus« by John Fowles and quite understood what the old fox was up to.

In December 1975 I went to Paris for the opening of an exhibition about the devil, for which I had designed a coloured poster. While I was there I went to Jodorowsky's studio and left my Paris address. Jodorowsky called me over and showed me the preliminary studies for *Dune*. Four science-fiction artists were busy designing space-ships, satellites and whole planets. As a gesture to me, a couple of photocopies of vaguely suitable pictures from my catalogue had been left lying around. Jodorowsky said that he would like me to try some designs – I could create a whole planet, and would have a completely free hand. Three-dimensional models would be made from my sketches and the actors superimposed on them. I could also design costumes and masks, etc. according to my own ideas.

My planet was ruled by evil, a place where black magic was practised, aggressions were let loose, and intemperance and perversion were the order of the day. Just the place for me, in fact. Only sex couldn't be shown, and I had to work as if the film was being made for children. Jodorowsky was fed up with having his films censored. A team of thirty specialists would transform my ideas into film. I was thrilled by the idea.

When we came to talking about money, he said: »You may be a genius, but we can't pay you as a genius.« When I asked him what the other contributors were getting, he said »Voss gets 4000 francs a month« – a modest salary indeed for a creative designer on a project costing twenty million. He explained to me at length what good publicity it would be for me, etc. We parted after we had agreed that he would telephone me about the salary, and he gave me the script so that I could start work right away.

On returning to Switzerland I was astonished to receive a telephone call from one of Jodorowsky's assistants saying that I should produce a view of the castle on the planet which we had spoken about, and bring it to Paris, where they would look at it and see if it was suitable for the film. Finally the film was realized by David Lynch – without me!

Such are the penalties of being a »Petit Suisse«.

P. 53 top: No. 289, *Dune I*, 1975
acrylic on paper, 70 × 100 cm
P. 53 bottom: No. 290, *Dune II*, 1975
acrylic on paper, 70 × 100 cm

P. 54/55: Furniture by H.R.G. in Château Gruyères (Switzerland) as part of the exhibition »Alien dans ses meubles«, 1990.
Photo: Rolf Neeser

Bottom left: Jutta and Bob Venosa, Cadaqués, 1975
Centre: Salvador Dalí, Cadaqués, 1975
Top right: H.R.G. with Dalí, Cadaqués, 1975
Bottom right: Amanda Lear, Dalí, Michèle, 1975

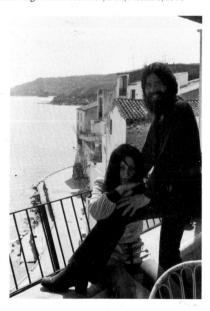

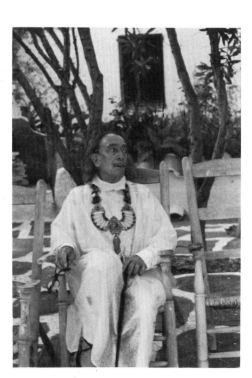

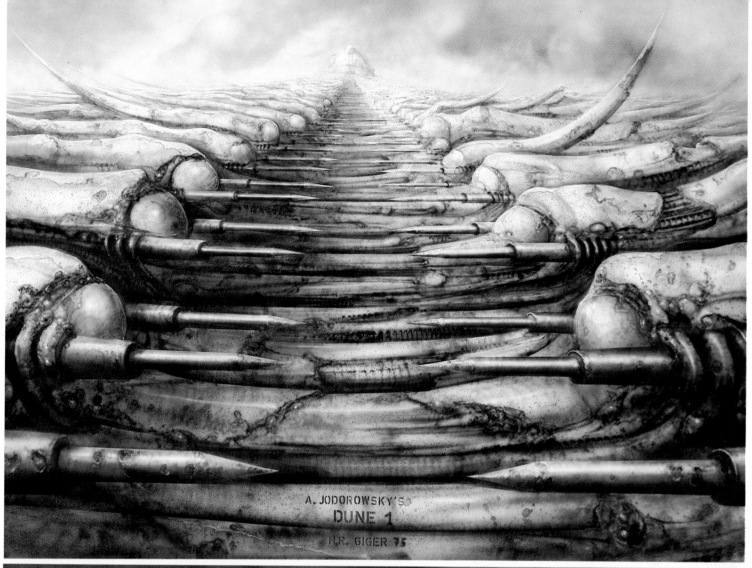

A. JODOROWSKY'S
DUNE 1
H.R. GIGER 75

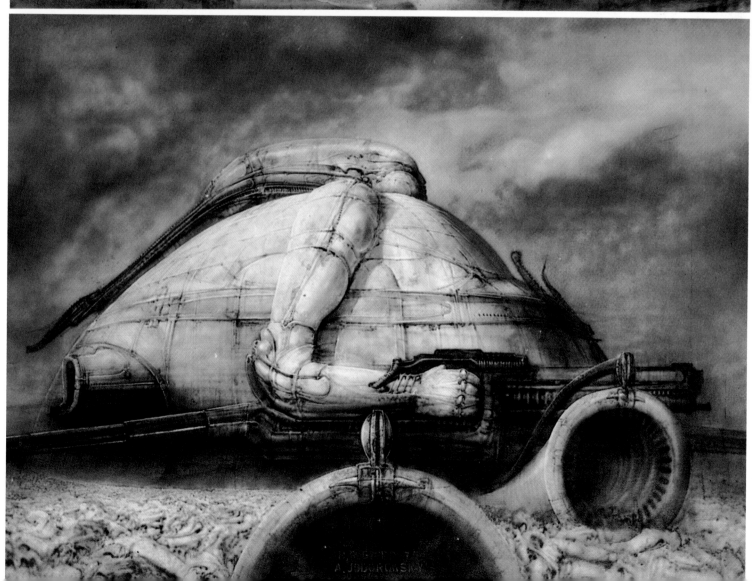

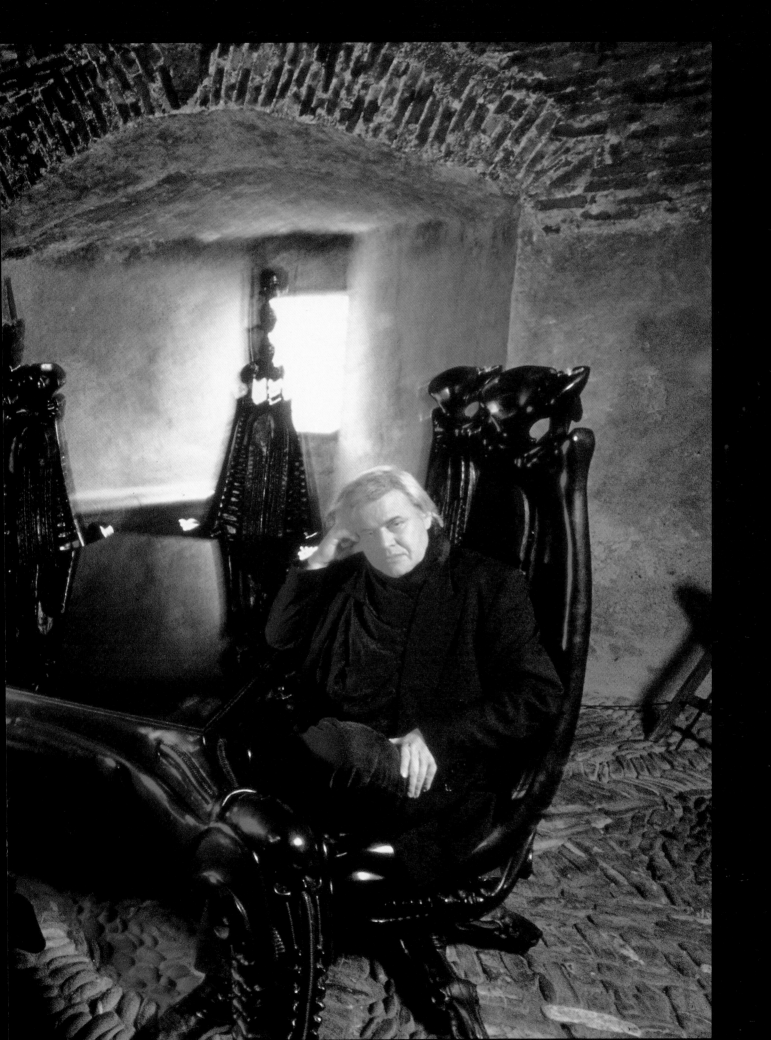

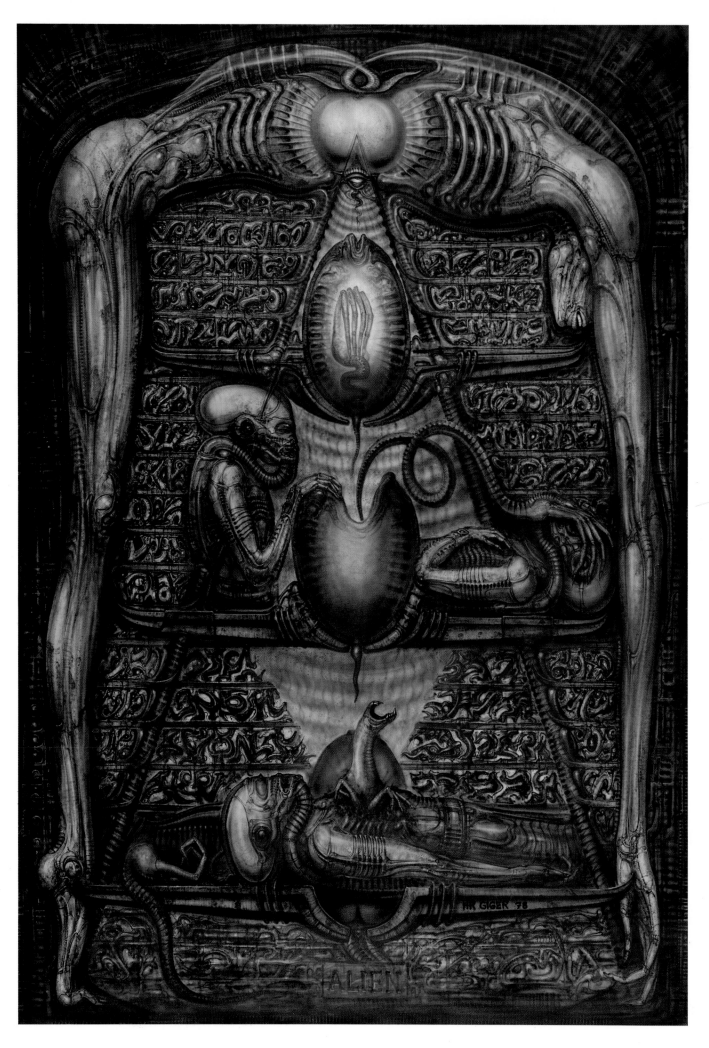

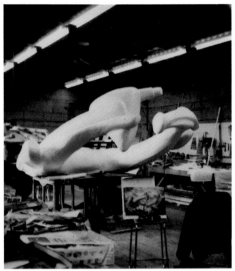

Alien aircraft model, Bray Studios

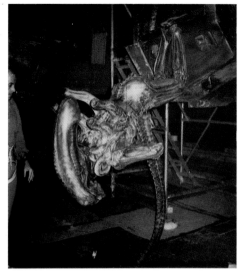

Alien during testing

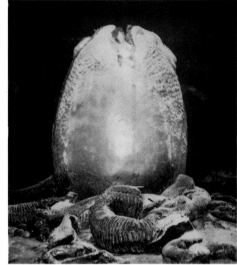

Alien egg

Alien

Having painted, in approx. three months, almost thirty pictures for the *Alien* project for Ridley Scott and Twentieth Century Fox, I was invited to England to supervise and execute the décor at Shepperton Studios. I had just fallen in love and Mia soon followed me over to England, having given up her job in Switzerland. In the Warren Lodge Hotel we were given the largest room with a beautiful terrace right on the Thames. We ate either in the hotel or at the King's Head pub, run by a charming couple. Penny, the publican's wife, was a blonde Italian and a wonderful cook. Whenever possible we sat in the small garden and, if it hadn't been for the stress and the tremendous time pressure, it might have felt like a honeymoon. But we felt so pressurized that we even worked in the evenings and on public holidays.

The Anchor pub, Shepperton

Mia on the terrace of the Warren Lodge, Shepperton

Shepperton, village square

The King's Head pub, Shepperton

Egg Silo

Alien

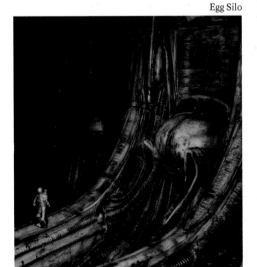

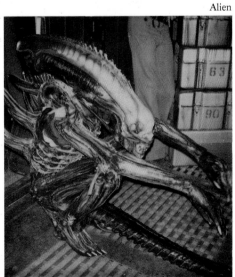

Ridley Scott and H.R.G.

P. 56: No. 384, *Hieroglyphs*, 1978
acrylic on paper, 200 × 140 cm

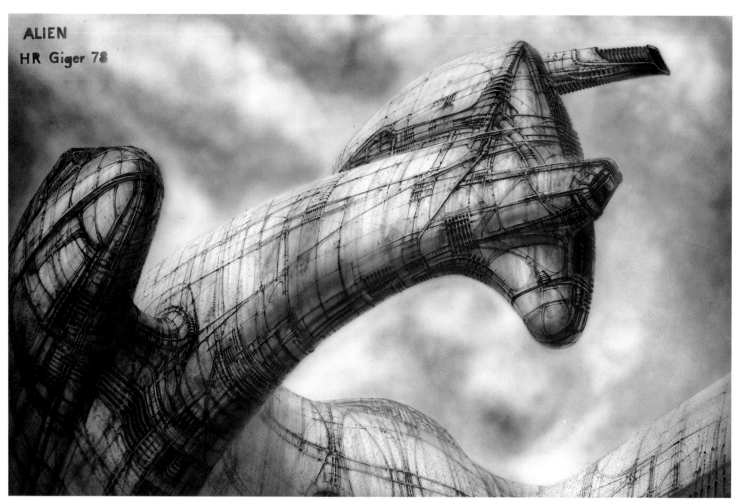

No. 396, *Wreck* (detail), 1978, acrylic on paper/wood, 100 × 140 cm

No. 380, Pilot in the cockpit of the Alien wreck, acrylic on paper, 100 × 140 cm

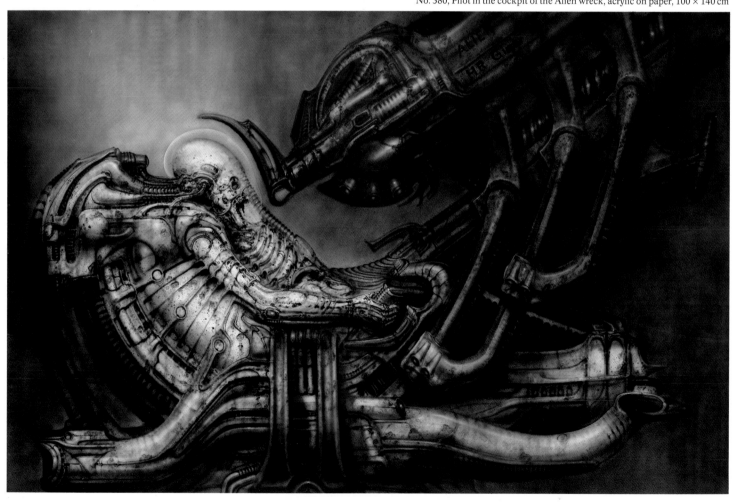

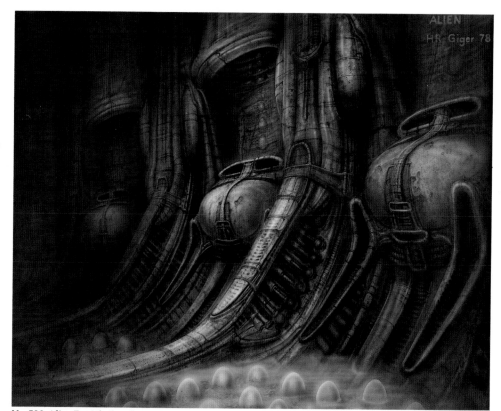

Mia working on the Alien head

H.R.G. working on the Alien head

Alien

I have seen myself how delighted you should be if just one scene turns out the way it was planned. I can understand why a director like Ridley Scott won't let a film out of his sight once he's started on it. I can also understand why, once the film has been released, he races from one cinema to the next in order to check the quality. I have seen, too, how important it is to have a director who is so versatile that he can step in as top man in any field. Only then can you hope for quality. In future I shall only work with directors I can admire. How much money you make along the way is unimportant, but when you've fanatically dedicated a year of your life to what ends up as a bad film that you will be forced to watch on TV for years to come – that's really depressing. You can't hide a third-rate film, unfortunately. So you can be secretly glad if you don't get a fair mention in the screen credits.

No. 386, *Alien Egg Silo* (interior version), Detail, 1978

Photos: H.R.G. and Mia Bonzanigo

Chestburster

Carlo Rambaldi with Alien head

Egg (seen from top)

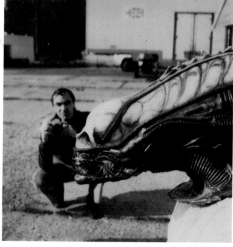

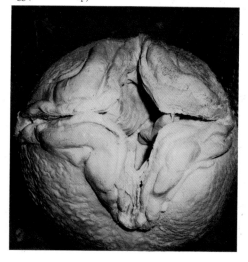

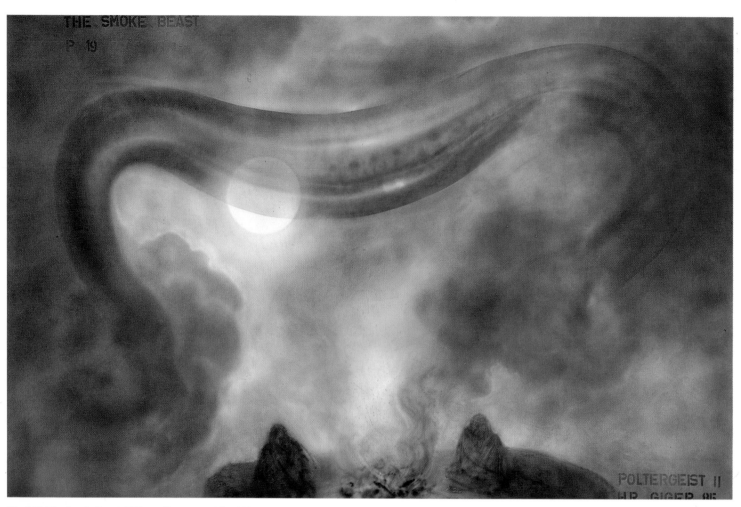

No. P. 19, *The Smoke Beast*, 1985, acrylic on paper, 70 × 100 cm

No. P. 20, *The Smoke Beast*, 1985, acrylic on paper, 70 × 100 cm

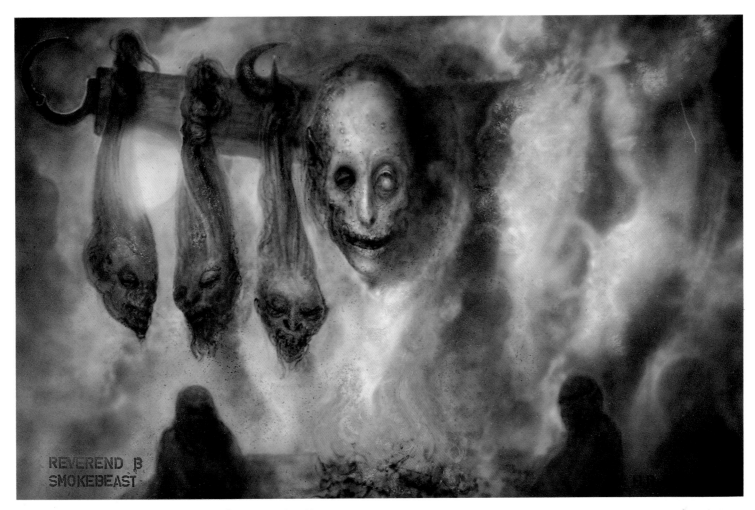

No. P. 26, *Reverend B/The Smoke Beast*, 1985, acrylic on paper, 70 × 100 cm

No. P. 27, *Reverend B*, 1985, acrylic on paper, 70 × 100 cm

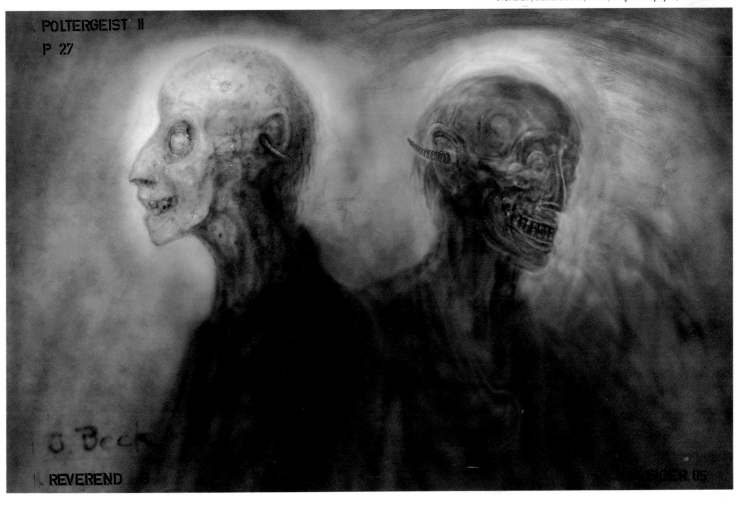

The Oscar Award

The designs and pictures for the film *Alien* were shown first in Zurich, in the Baviera gallery, and then in the Musée Cantonal des Beaux-Arts in Lausanne. I was nominated for an Oscar. Twentieth Century Fox paid for my flight and stay in Los Angeles. Accompanied by Mia, Ueli Steinle and Bijan Aalam, I travelled to the USA. We made a short stopover in New York in order to celebrate my vernissage in the Hansen Galleries, New York. Bob Giuccione had published my erotic pictures in a fourteen-page colour article in the American *Penthouse* – and now this extravagantly sponsored vernissage. On 14 April in the Dorothy Chandler Pavilion, I was awarded an Oscar for »Best Achievement for Visual Effects« for my contribution to the film *Alien*. The press commotion surrounding *Alien* started that very night. After three days of interview stress, my companions and I returned exhausted to Switzerland, where we were then »pumped« by the Helvetian media.

I began a series of pictures using airbrush and plate templates, which I called the *N.Y. City Pictures.* Various filmmakers, above all from the USA, sought to win me for their film projects. Ridley Scott, the director of *Alien*, asked me to collaborate on another project, *Dune*, for which Dino di Laurentiis already had the rights. After brief negotiations, the project was shelved for financial reasons.

I purchased the next-door house in order to expand my studio space. (In the same year I became a member of the American Academy of Motion Picture Arts and Sciences.)

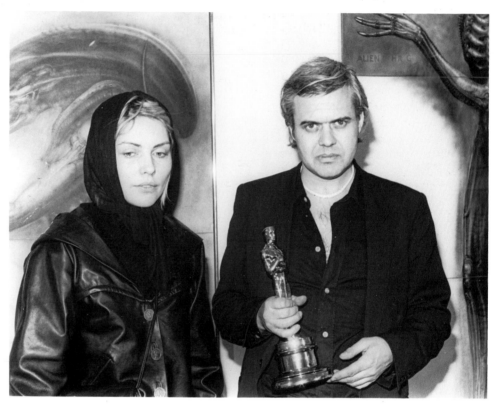

Debbie Harry and H.R.G. in the Hansen Galleries, N.Y.
Photo: Bill Stone, N.Y.

Press cuttings from the Swiss press on the occasion of the Oscar Award

Blondie, Debbie Harry

I first heard Blondie's music in 1978, while we were at Shepperton Studios with *Alien*; I discovered punk at the same time. I constructed a pair of sunglasses in the shape of a huge safety pin to be stuck through the nose. When Debbie rang and asked if I would do her record cover, I visualized her as the Queen of the Punks. On the *Koo Koo* cover, the safety pins have become acupuncture needles symbolizing stimulation, electricity and power, which come from the air. I stuck the needles through Debbie's head and only later realised that the needle by her eyes meant fire, the one by her nose air, the one by her mouth water and the one in her neck earth. The fifth needle in the video represents the spirit. I worked »surrealistically«, without stopping for reflection. It is only afterwards that you find out exactly what everything means and can explain it.

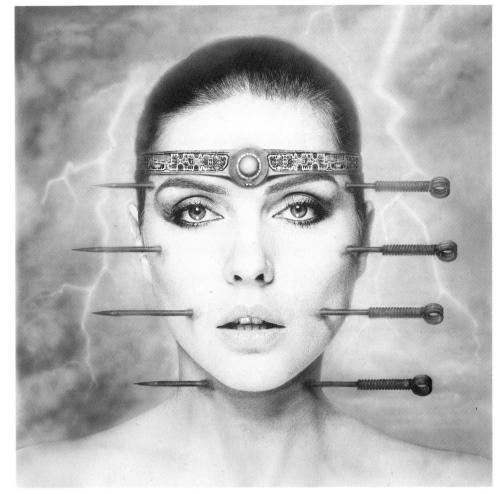

No. 472b, *Debbie II*, 1981, acrylic on photograph, 100 × 100 cm

No. 471b, *Debbie I*, 1981
acrylic on photograph, 100 × 100 cm

No. 473b, *Debbie III*, 1981, acrylic on photograph (cover), 100 × 100 cm

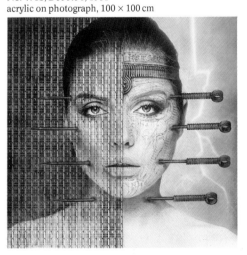

H.R.G. in his studio

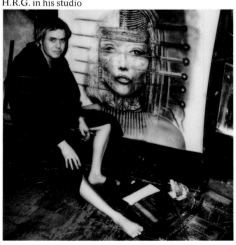

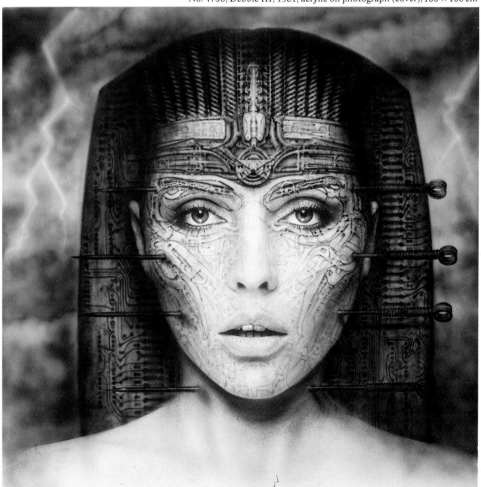

Japan

After a lengthy preparation phase, a total of two tonnes of exhibits were sent off to Tokyo in February 1987. The show featured the original *Alien* monster and one of the Harkonnen chairs. Pictures included themes from the films *Giger's Alien* and *Poltergeist II* and other originals. A total of fifty pictures were on display. I painted a number of works entitled *Japanese Excursion* especially for this exhibition.

On 26 February the exhibits were laid out and hung following my supervision and instructions. The Seibu Museum of Art's Seed Hall in Tokyo was immense, and every work could be shown to its best advantage.

The exhibition unleashed a real Giger boom in Japan. In Tokyo it attracted around 2000 visitors a day, and a Japanese Giger fan club was founded (see Index for address). Steinle and I used the Tokyo trip to discuss various projects. The most important result of these talks was, however, my commission to create the monster Goho Dohji for a film by the Japanese director Akio Jitsusoji. Plans were also discussed for the building of a Giger bar in Tokyo.

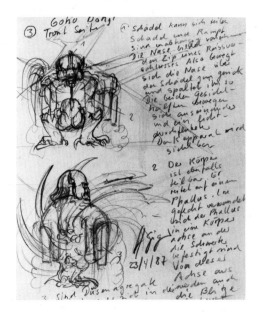
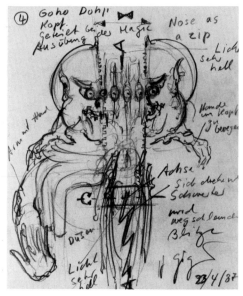

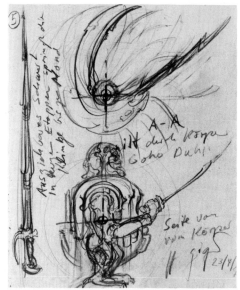
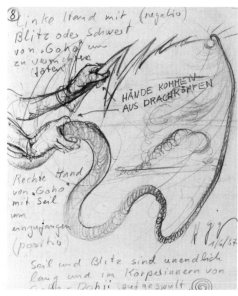

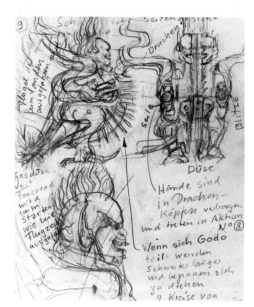
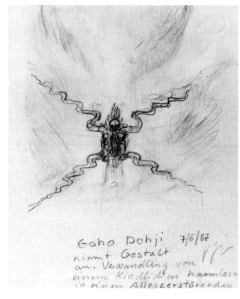

From H.R.G.'s sketchbook

Top left: Model of the Giger Bar, Tokyo,
by Conny de Fries
Bottom left: Entrance to the Giger Bar, Tokyo
Photos: S. Ouvehand

▷ No. 18, *Goho Dohji*, 1987
acrylic on paper, 140 × 100 cm

P. 66: Ink and pencil drawings, 1985
paper, 30 × 21 cm

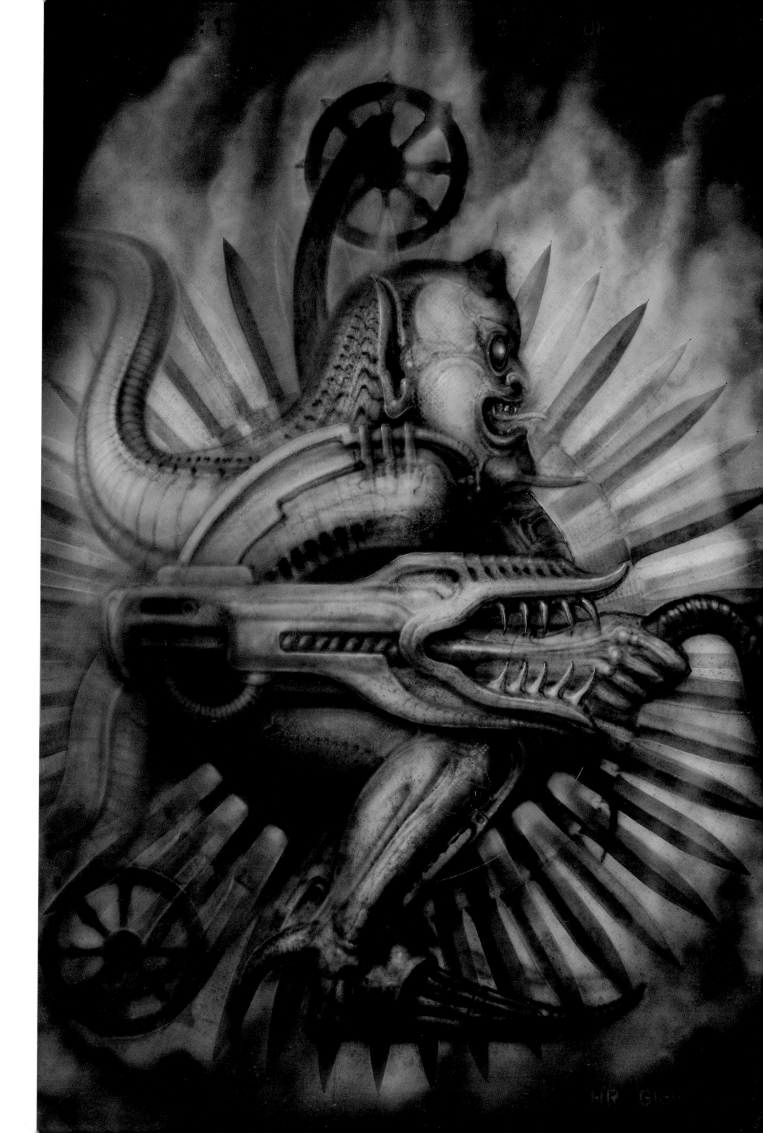

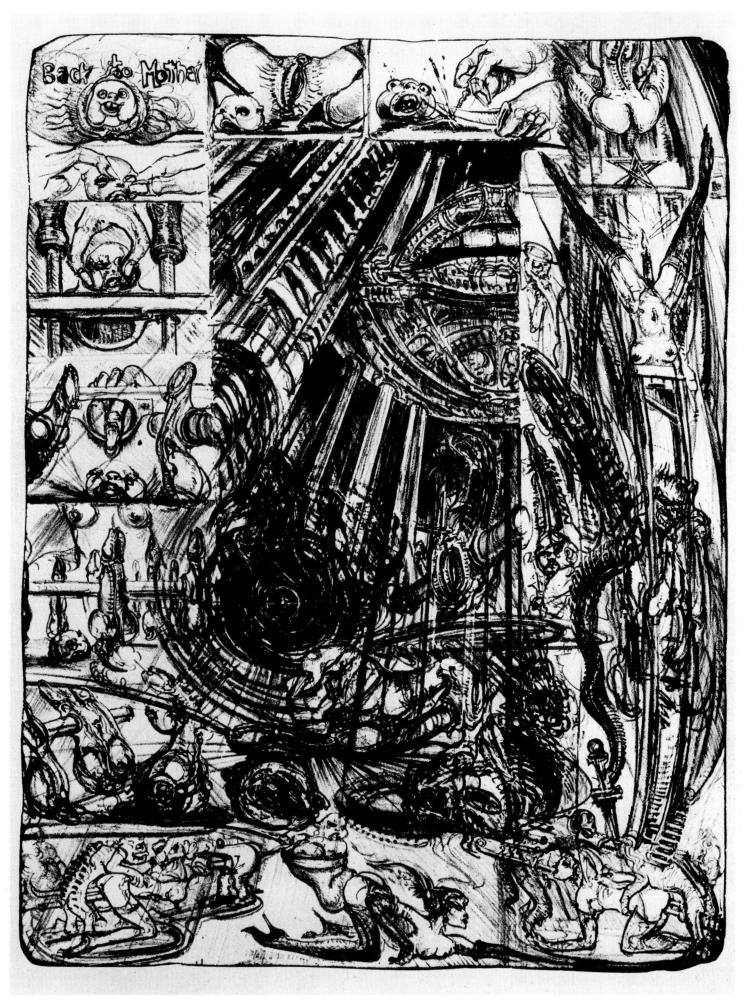

Back to Mother, 1986, original lithograph, single-colour, 3rd state, 57 × 46 cm

Melly Giger, 1989. Photo: Panja Jürgens

▷ No. 113, *Passage II*, 1969, oil on wood, 54 × 46 cm

Melly Giger-Meier

My mother is a wonderful, kind woman whom everyone has always envied me for. She was always very practically-oriented. While lying in hospital with me – my father was on active service – and searching for a boy's name, the black glass plate with the gold inscription which adorned our pharmacy may have swum before her eyes. For she gave me the initials H.R. – Hans Ruedi – like my father, Dr. Hans Richard. I didn't make it to »Dr.«. A shame, if only for the sake of the plate.

I recently asked my mother what my birth had been like. She recalled that I had always wanted to get out but that I had taken too long about it. Thus the object in *Passage I*, which is shaped like a paper-clip and which blocked my way into the world, is probably part of a pair of forceps. How horrible.

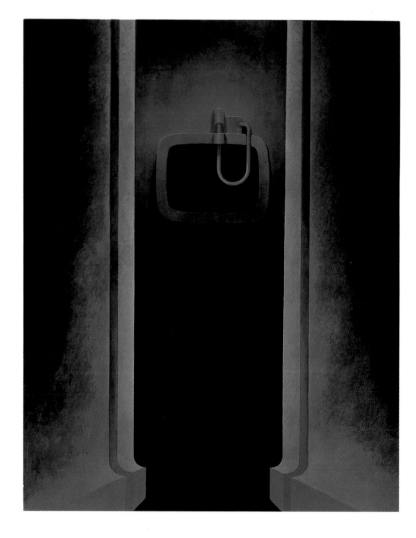

No. 116, *Passage IV*, 1969, oil on wood, 100 × 80 cm

68

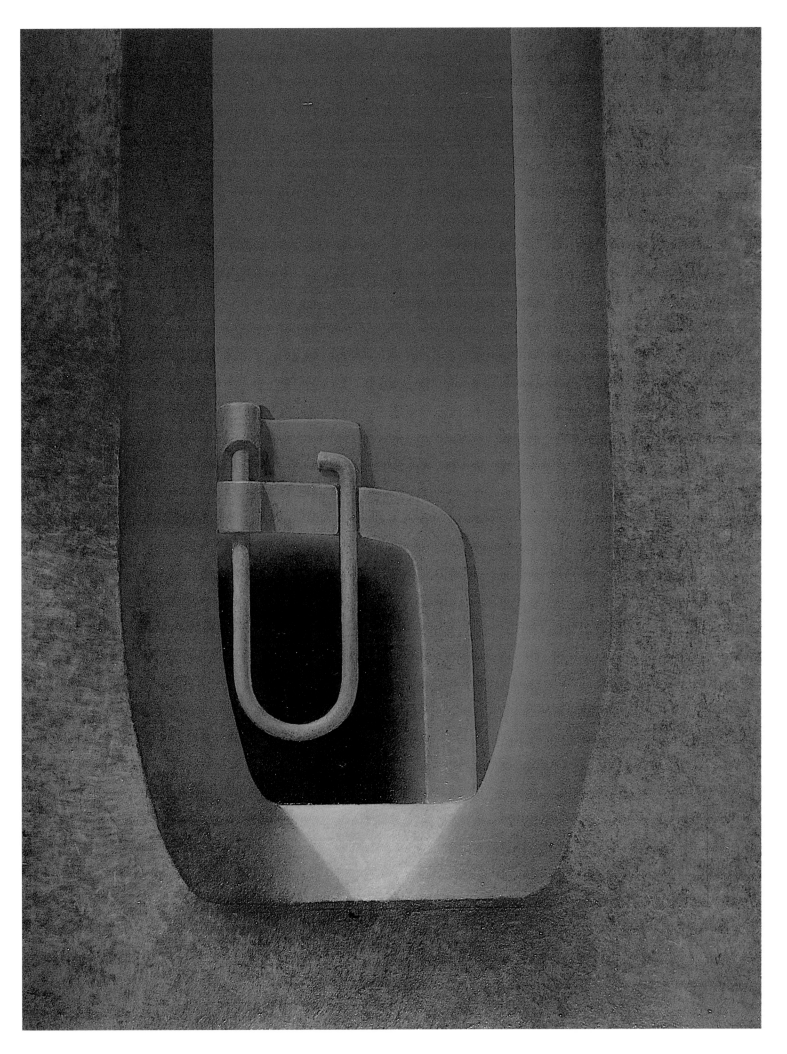

Passages

While in Cologne on my way to London in 1971 I saw German refuse collection in action for the first time, in front of the »Floh de Cologne« house. I was so fascinated by this mechanically erotic act, the prelude to a »final solution« for these overflowing dustbins, that I quickly shot a couple of photos. I am now using psychedelic painting in an attempt to impose every possible reality onto this new, existent passage, in order to preserve the maximum possible objectivity of a thing which might have been created specially for me (ill. p. 71–73).

F. M. Murer had been living in the centre of London for over a year. A reason for myself and Li to visit England. Murer and I decided to make a documentary film called *Passagen* (Passages) on my pictorial world. London's mysterious docklands provided the first locations. *A RH +*, the first catalogue of my works, appeared through the Walter Zürcher Verlag, Gurtendorf, Bern canton.

▷ Leaflet: Asylum for Timothy Leary, 1971

P. 71: No. 184, *Passage XXIV*, 1972, acrylic on paper/wood, 100 × 70 cm

Refuse collection, Cologne. Photos: H.R.G. (*Refuse Passages* 71–73)

Asylum for Timothy Leary!

3 July 1971

The attempt to criminalize and outlaw Timothy Leary for »drugs offences« does not hold good, a view shared by well-known lawyers in the USA. As a trained doctor and professor of psychology, as the initiator of an association with hundreds of scientists as its members, he felt himself fully entitled to undertake *free trials*. Those who describe him as a »prophet« of the Basel-developed drug LSD should also be aware that he and his friends utterly condemn the use of this substance without expert monitoring and demand a year of mental and physical preparation prior to self-testing. No one has spoken out more strongly against the poisons of barbiturates, amphetamines etc. which are legally available in some countries. His protests have saved hundreds of thousands from hard drugs (morphine, heroin etc.).

His enemies in the USA have written openly of *the true reasons for their hatred* against him, however, and have expressly declared him an »enemy of the state«. The fact that, thanks mainly to his efforts, some 15 % of the white youth in the USA are *against the destruction of the environment, the Vietnam War and the oppression of Indians and Blacks* fills certain groups with blind fury.

As participants in the artistic campaigns of the sixties, we know that not much has emerged in Europe over the last ten years in the fields of *music, painting, poetry, psychology and the search for a new lifestyle* which cannot in some way be linked to the name Leary. In America, thanks to him, studies of C.G. Jung and Hesse reached their peak. He was decisively involved in the *rediscovery by a whole generation of the cultures of India and the American Indians* – and thus in the confrontation of modern-day youth with the world of a new religiousness.

Hugo Ball once wrote that every revolutionary thinker had sought asylum in Switzerland for a while at some time or other, and saw the purpose of our country as *a place of free encounter and the spread of new ideas*. Are we less generous than our 19th-century compatriots?

With all the means available to us we will do everything to prevent a *betrayal of the principles of Switzerland* and any subsequent washing of hands. In a democracy there may be no silent majority. Still less a *silent minority*.

For »Group Action Asylum for Leary«:

Sergius Golowin, author, Bern
Hansruedi Giger, painter, Zurich
Walter Wegmüller, painter, Basel

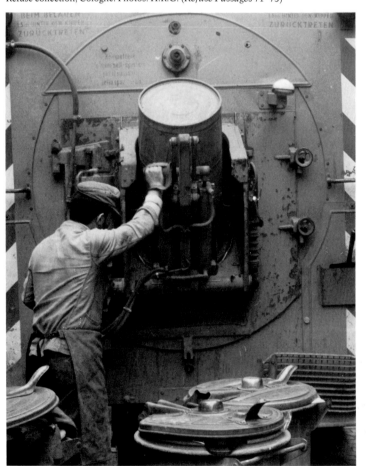

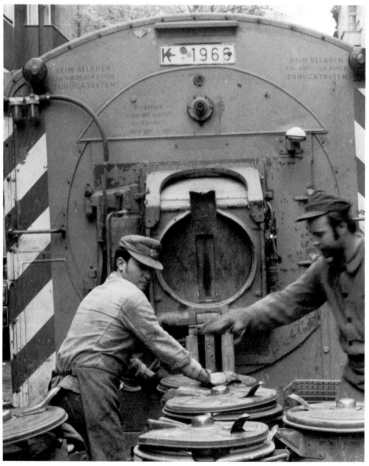

No. 173, *Passage XVII*, 1972, acrylic on cardboard/wood, 100 × 70 cm

No. 172, *Passage XVI*, 1972, acrylic on cardboard/wood, 100 × 70 cm

No. 174, *Passage XVIII*, 1972, acrylic on cardboard/wood, 100 × 70 cm

No. 177, *Passage XXI*, 1972, acrylic on cardboard/wood, 100 × 70 cm

No. 236, *Passage XXXIII*, 1973, acrylic on cardboard/wood, 100 × 70 cm
No. 224, *Passage XXVII*, 1973, acrylic on cardboard/wood, 100 × 70 cm

No. 232, *Passage XXIX*, 1973, acrylic on cardboard/wood, 100 × 70 cm
No. 182, *Passage XXII*, 1972, acrylic on cardboard/wood, 100 × 70 cm

A True Story of the Occult

I shall be telling this story right down to the last detail since – as a truth fanatic – I would like as many of its facts to be verifiable as possible.

This story is chiefly about the question of whether an object can be »evil«.

A few years ago I obtained from a friend of mine – the gallery-owner Bijan Aalam, to whom I owe the large part of my occult collection –, the wooden head of a devil, hollowed out and, according to Bijan, covered with human skin. The neck ends in a ruff of raffia, like a chianti bottle. This object came from the estate of Pierre Molinier, a fetish artist who once predicted that the day his penis went limp he would kill himself. In the end he did actually shoot himself.

The origin of the head, which features three small curving horns, is still a mystery. It is thought to be about 100 years old and to have served as a ritual object in black masses or similar ceremonies. It cannot have been used as a mask, however, since the neck opening is too small. It may have been worn on top of the head, and it was hollowed out chiefly to reduce its weight. More I do not know. I put the head on the Chinese cupboard in my bedroom and forgot about it.

Some time later, during a visit from my friend Bijan, I complained of the severe depressions I had recently been suffering and for which I had no explanation. Bijan noticed the devil's head on my cupboard and suggested my condition might have something to do with the influence of this object, which he knew to be accredited with malignant powers.

He recommended I stow it away in the cellar. I followed his advice and, putting it in a white plastic bag in a cardboard box along with other treasures, took it down to the cellar and forgot about it.

I hate to be superstitious; I see it as a great weakness which takes away a person's freedom and can drive him to madness. Superstition can encourage chance, so that you yourself can unconsciously help things happen.

I genuinely try not to be superstitious, and I also avoid everything to do with sects and religious fanaticism, since I've had my own experience of such things. A few years ago, on Friday, 23 March, a red poster based on a picture from my *Victory* series – Work No. 516 V, entitled *Satan* – was printed in five colours as publicity for the magazine »Team« (No. 4, April 1984). The fifth colour – the printing process normally only uses four col-

ours – wasa red-orange which heightened the impact of the picture enormously. That day I arrived home with the first proofs from the firm of I.C. Müller in Seefeld, Zurich. I had recently tidied up the cellar and had rediscovered the devil's head, which I had placed on the living-room table. I was on top form because the printers had done such an excellent job; I looked at the head and thought about putting in on a presentation stand.

That evening I was invited to a party (Tango Palace) being held by my ex-wife Mia in Albisgüetli. My friend and collector W. also wanted to come along with his girlfriend B., and suggested I go to them first and that we all drive to the party together. As a present I took him a proof, fresh off the press, which W. admired at length and then hung on the wall with great enthusiasm.

The flaming red impressed everyone. That night B. wore a magnificent, brand new black-transparent dress, made of a sort of viscose feather tulle, which W. had bought for her. She was generally admired among the relatively exclusive, small circle of tango fans whom Mia had drummed up. A sculptor had set himself up in the same room and was coaxing people into sitting for a plaster cast, a so-called death mask. We went up to his table, and I too tried to convince B. to have a cast made of her beautiful face. On the low tables scattered around the room stood small red candles. B. was leaning against one of these tables. Learning that the sculptor intended to keep the casts for himself, I wanted to advise her against it – but she had already caught fire. In a flash the flames had leapt from her sleeve to her thin viscose dress, and B. was burning like a torch. W. stood as if transfixed while I tore off my jacket and we then attempted in vain to smother the searing flames.

The victim rolled around the floor as if demented. At last the flames went out, and we put B. under the shower in the cloakroom. Mia had meanwhile called the emergency services and soon the rescue team arrived, wrapped B. in a blanket and the nightmare was over. Some of the guests hadn't even been aware of the accident. For W. and myself, however, the pleasure had gone out of the party which had begun so well.

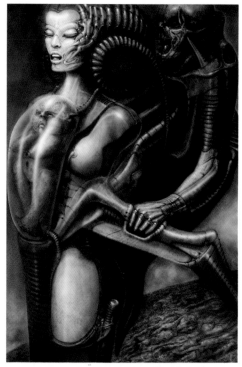

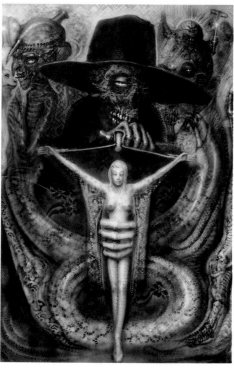

Top: No. 327, *Preparing for a Sabbath*, 1976
acrylic on paper/wood, 100 × 70 cm
Bottom: No. 325, *Satan II*, 1977
acrylic on paper/wood, 100 × 70 cm

▷ No. 341, *Witches' Dance*, 1977
acrylic on paper/wood, 200 × 140 cm

No sooner was I home than I wrapped the cursed fire devil back in the plastic bag and took it straight back down to the cellar. B. received third degree burns and had to suffer a great deal of pain and multiple operations.

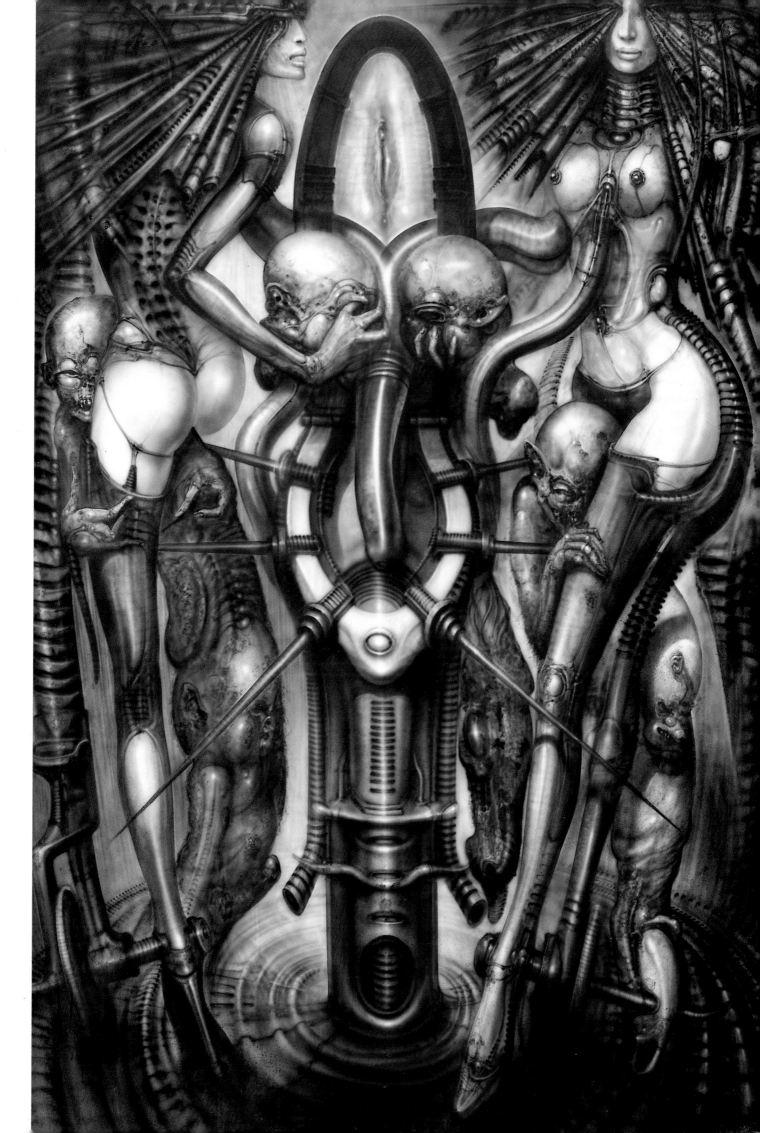

Urs Tremp with devil's head
Photo: H.R.G.

Occult-Story II

This event numbers among the strange coincidences which ultimately seem predetermined. The next »coincidence« took place on Monday, 27 June 1988. I was busy with my assistant Ralf preparing exhibition material for an event to be held in the St. Gallen Stadttheater. The event was called an »Alchemy Symposium« and had been organized by Urs Tremp and Armando Bertozzi. It was my task to furnish an approx. six-foot-high glass cabinet with various items, whereby I wanted to show a mixture of banal and magic objects. We selected exactly 27 exhibits, which then lay ready on the table to be picked up the following day. The devil's head, which Ralph had listed as No. 22 under the name »Devil's Skull«, had not seen the light of day since that terrible night four years earlier. Once we had finished compiling our list, we went and sat in the garden. At about 6 p.m. we suddenly heard an almighty bang followed by agitated voices from the next-door garden. Ralf and I looked at each other; it was clearly a warning from the devil's head. So I put it back into its plastic bag and returned it to the cellar. Outside the wind was getting up. Ralf, afraid of getting caught by the rain on his moped, immediately set off home. I rang my mother. Between five and seven minutes had elapsed since the bang when someone knocked loudly at the door. The neighbours told me excitedly that my large cherry tree had slowly toppled over into their garden, and had landed exactly where they had been sitting in the sun so shortly before. They seemed distraught. I immediately followed them outside and found that the huge tree indeed appeared to have been severed at a height of about eight feet. Lightning had somehow struck the tree and sliced through the trunk. It hadn't fallen immediately, but had supported itself on the branches of the neighbouring trees until the arrival of the strong wind finally brought it down. Without this delay of just a few minutes, the people underneath might have been crushed.

I told Tremp the story when he came to collect the exhibits the next day. All his efforts to persuade me to exhibit the head were to no avail. I had been warned and didn't want to run any more risks, for to include the devil's head in the exhibition would be to put our lives and the pictures at stake. I was happy to do without it. This time superstition had got the better of me.

Were I to photograph the fiend for this story, then only in the cellar.

No. 516, *Victory V (Satan)*, 1983, acrylic on paper/wood, 70 × 100 cm

▷ No. 324, *Satan I*, 1977, acrylic on paper/wood, 100 × 70 cm

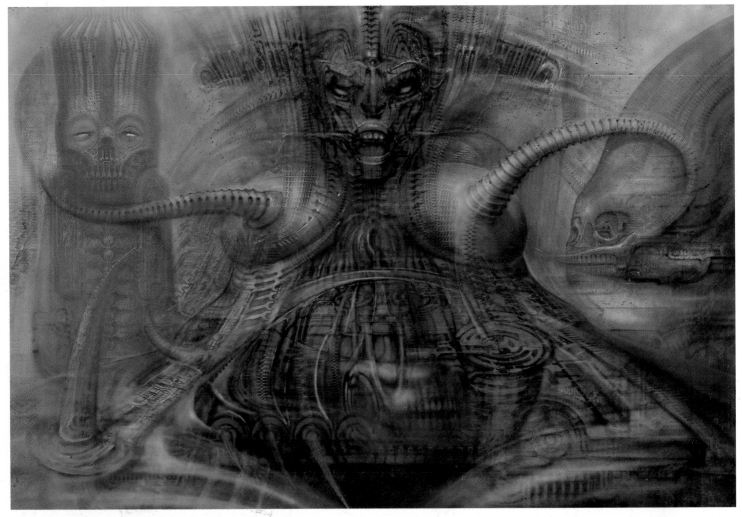

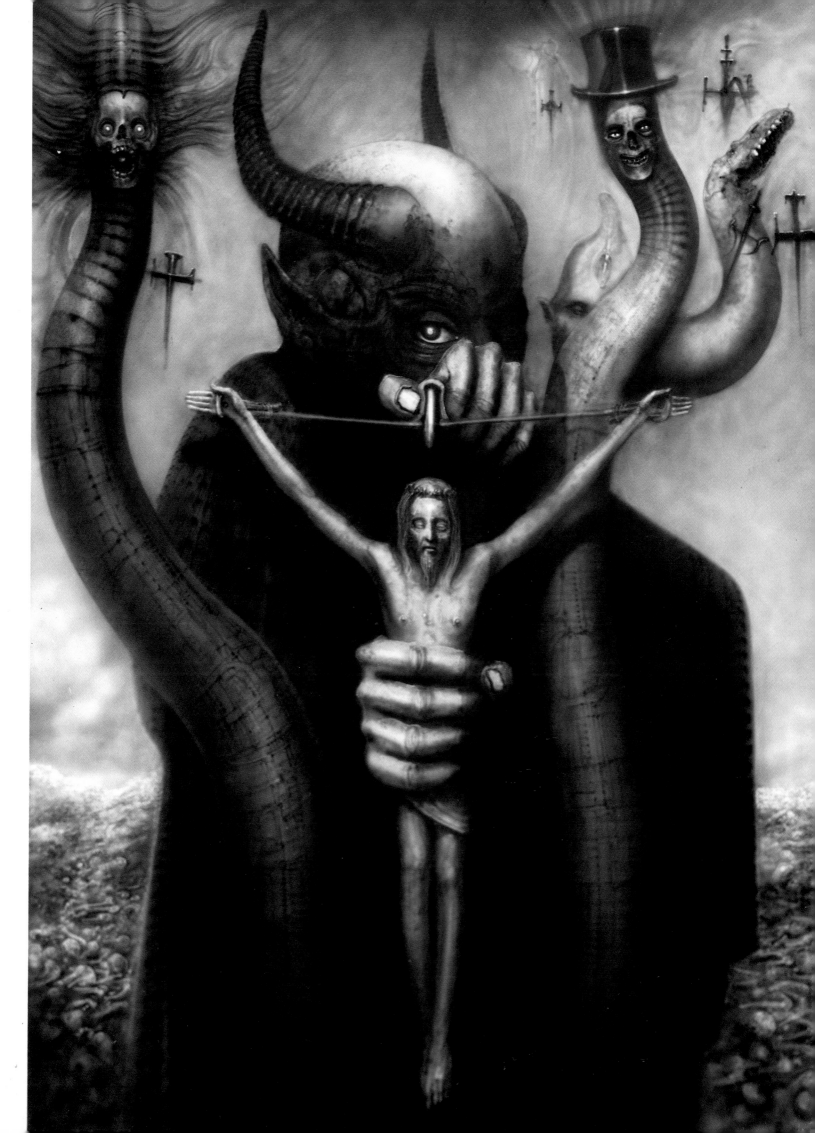

C. Muriel and Joel Vandroogenbroek, 1980
Sound engineers for *Giger's Necronomicon*, 1975,
and *Gigers's Alien*, 1979.

Top right: No. 218, record cover for »Brain Salad
 Surgery« by Emerson, Lake & Palmer, 1973
 acrylic on paper, 34 × 34 cm
Bottom right: No. 217, record cover for »Brain Salad
 Surgery« by Emerson, Lake & Palmer,
 1973
 acrylic on paper, 34 × 34 cm

P. 79: No. 276, *The Magus*, 1975
acrylic on paper/wood, 200 × 140 cm

The Saxophonist, 1965,
ink and pencil

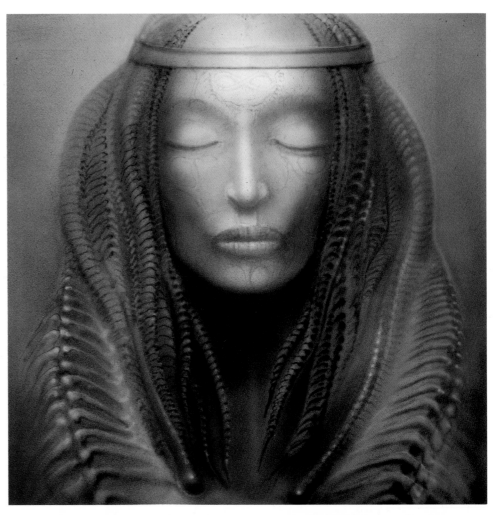

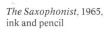

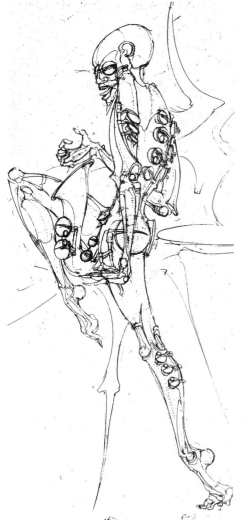

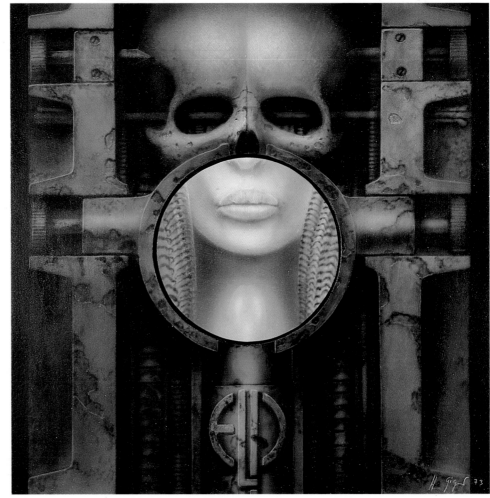

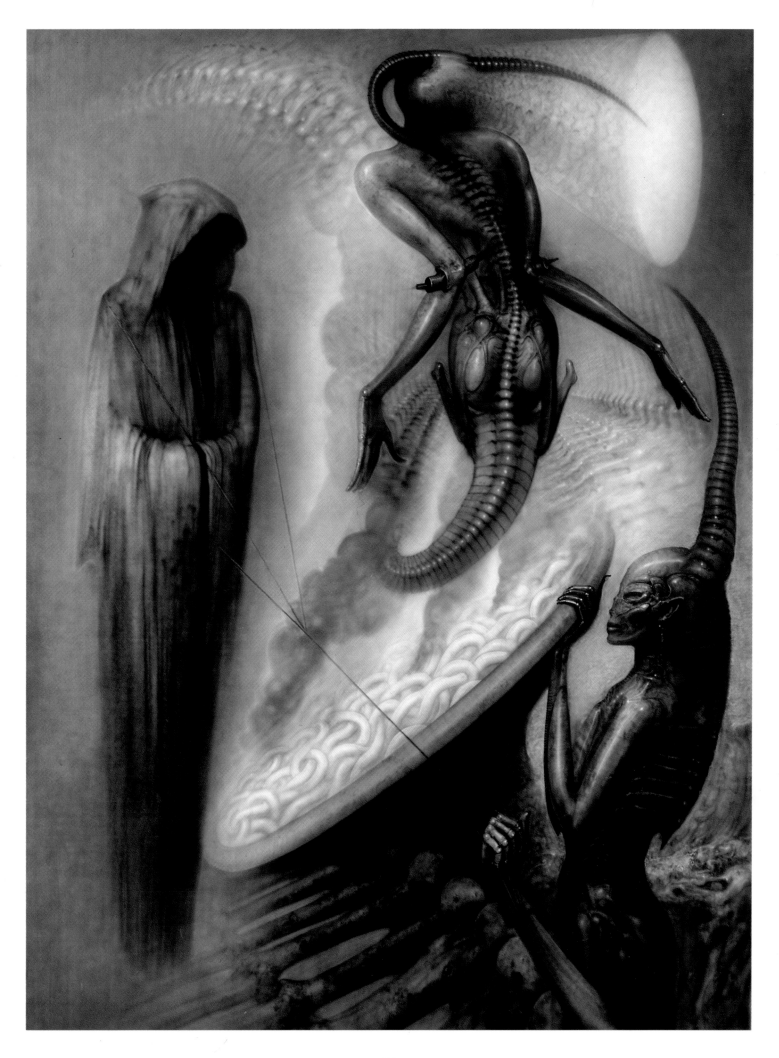

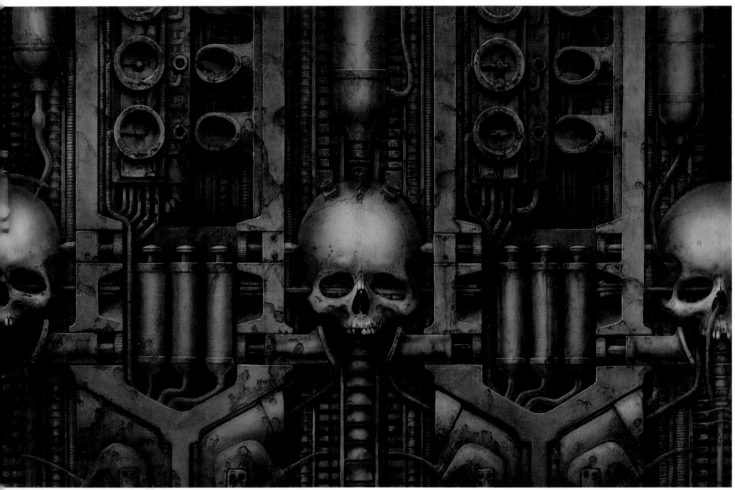

No. 216, *Landscape XIX*, 1973, acrylic on paper/wood, 70 × 100 cm

No. 219, *Landscape XX*, 1973, acrylic on paper/wood, 70 × 100 cm

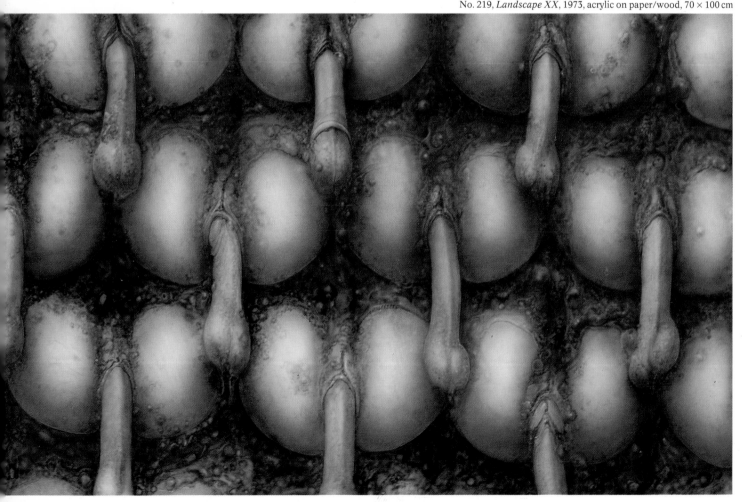

Punk-Band muss weg... Porno-Bild von Schweizer... Maler Giger vor Gericht...

SAN FRANCISCO – Ein Gemälde des Schweizer ... «Oscar»-Preisträgers Hansruedi Giger (46) wird zum ... fall: Die Punk-Band «Dead Kennedys» hatte ihrer letzte... sehr freizügiges Giger-Bild beigelegt. Am 2. September... sich die vierköpfige Band deswegen in San Francisco vor ... richt verantworten – wegen Verbreitung von Pornographie.

Das von den kaliforni-schen Sittenvögten bean-standete Gemälde Gigers mit dem Titel «Penis Lands-cape» zeigt eine Sex-Vision, unzählige weibliche und männliche Geschlechtsteile während des Verkehrs.

Unterdessen ist die Punk-Scherbe in Amerika und England nur noch ohne das Giger-Poster im Verkauf.

Für Jello Biafra, Band-Leader der «Dead Kenne-dys», die bei einer Verurtei-lung mit einer Gefängnis-strafe bis zu einem Jahr rechnen müssen, ist die ganze Sache «ein Kabarett». Die Band wird ausserdem be-schuldigt, LPs mit den Giger-Bildern an Minderjährige verschenkt zu haben.

● **Hansruedi Giger (46)**

Hansruedi Giger, der das Bild den «Dead Kennedys» verkauft hatte, mag sich zu diesem P... läufig ni... Manager: noch ha... nicht eing...

Giger-Gemälde nicht pornographisch

Die Anklage wegen Pornographie gegen den amerikanischen Punkmusiker Jello Biafra ist niedergeschlagen worden. Bia-fra, Sänger der «Dead Kennedys», war angeklagt, weil er einer Schallplatte ein Poster des Schweizer Künstlers H.R. Gi-ger beigelegt hatte (TA vom 24. August).

Ein Richter in Los Angeles ordnete die Niederschlagung der Anklage an, nach-dem ein aus zwölf Personen bestehendes Geschworenengericht erklärt hatte, kein einstimmiges Urteil fällen zu können.

Sieben jüngere Mitglieder der Jury woll-ten Biafra freisprechen, fünf ältere Ge-schworene hielten Gigers Bild «Penis-Landscape» für pornographisch und er-kannten auf schuldig.

Der Rechtsanwalt von Biafra hatte ar-gumentiert, das Poster sei nicht porno-graphisch, weil dessen Vorlage, das ori-ginale Giger-Gemälde, seit fünfzehn Jah-ren in vielen Ausstellungen gezeigt und in vielen Kunstbüchern reproduziert wor-den sei.

(SDA)

H.R.G. at his first exhibition in New York, »Images of Horror and Fantasy«, Bronx Museum, 1978

Die fantastischen Bilder des Schweizer Künstlers H.R. Giger – sind verständlicherweise nicht je-dermanns Sache. Dass sie jetzt aber zur Gerichtssache in den USA gerieten, dürfte auch nicht jedem verständlich sein; denn wer sich einen Giger kauft, ist schliesslich selber schuld. Stein des Anstosses ist ein Gi-ger-Poster namens «Penis-Land-schaft», das einer Schallplatte der amerikanischen Punk-Band «Dead Kennedys» beigelegt und vor Gericht eingeklagt wurde. Da kann man nur wiederholen: Wer sich eine solche Platte samt Po-ster kauft, ist selbst selber schuld. Wer sich selbst ein Bild von den Bildern Gigers machen will, schaut sich im ZDF am 3.9 «Das fantastische Universum des H.R. Giger» oder am 5.9. den Film «Alien» an.

Accusée d'ê... ...no

Toile de Giger au centre d'un procès

No. 215, *Landscape XVIII*, 1973, acrylic on paper/wood, 70 × 100 cm

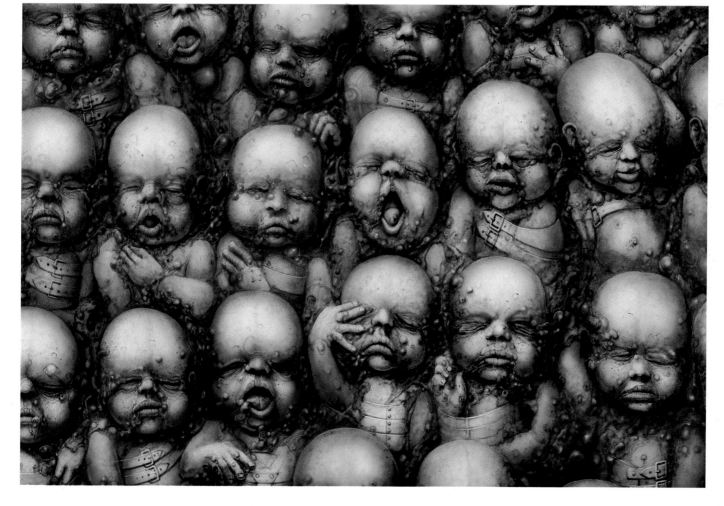

P. 81: Newspaper cuttings ot the occasion of a court case in San Francisco in 1976: Illustration No. 219 (P. 80 bottom) enclosed in a record by the punk band »Dead Kennedys«, was unambigously classed as »art« and therefore not pornography.

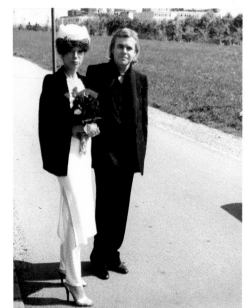

P. 83 top: No. 420b *Erotomechanics V*, 1979 acrylic on paper/screen print, 70 × 100 cm

P. 83 bottom: No. 421b, *Erotomechanics VI*, 1979, acrylic on paper/screen print, 70 × 100 cm

P. 84: *The Mystery of San Gottardo* (detail), 1990 marker pen on paper, 42 × 42 cm

◁ H.R.G. and Mia before their wedding

Erotomechanics

After the PR commotion and stress and Oscar awards, Mia and I married on 28 August with just close friends and no church ceremony. Ueli Steinle, who had taken over my management, organized a wonderful celebration. Six of us spent a perfect summer's day at the Ugly Club and on the private island it owned in Lake Zurich, where I promptly lost my – somewhat loose – wedding ring while swimming. I felt terrible when I realized, but since I had no way of magicking up a new one, there was no alternative but to confess. No one actually said it, but everyone had the same thought: it might bring bad luck.

Inspired by work on the film *Alien* and above all by Mia's love charms, I produced *Erotomechanics*, a series of pictures of which six were compiled into a screen-print portfolio. After 1½ years the dream was over. I had already begun the *N.Y. City* series on the deserted, cold and soulless architecture of New York, which now accurately reflected my inner despondency. I threw myself into painting as a means of escape. The situation improved when Mia moved into her own apartment on the other side of town. Today we are excellent friends.

Above centre, left: Wedding guests (from left to right): Judith Morf, Dino Zerbini, Michel Zerbini, H.R.G., Mia
Above centre, right: Mia as model for *Erotomechanics*
Below centre, left and right: Wedding-party swim during which H.R.G. lost his wedding ring.
Bottom: Mia and H.R.G. dancing
Photos: U. Steinle

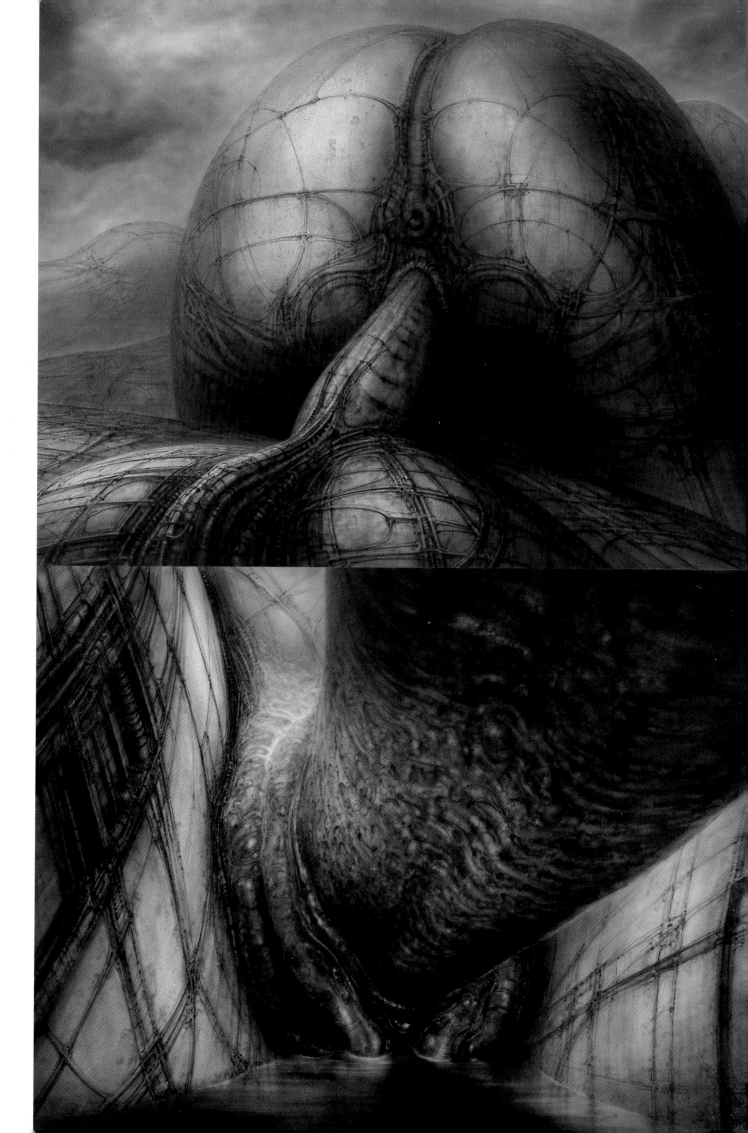

Cthulhu Rising

Heroin, after being internationally legalized, rapidly became a scarce commodity. It could only be afforded by the rich, the politicians and the scientists, themselves ultimately responsible for the catastrophe, since bulk-buying by half of humanity had cleaned out the market. The temperature on earth had risen by a few degrees and long-held fears were now becoming reality. Melting icebergs were producing floods everywhere. After every dramatic announcement, anyone who could gave himself a fix. Only the humanoid augurs monitoring the earth's most important points remained alert. Strange things happened at some of the natural entrances to the earth's interior. Just a small number of initiates, assistants and servers of the Ancients were busy day and night preparing for the day when the ancient gods would finally take up power on earth. Old, hard-to-find books of spells, such as the legendary NECRONOMICON by the mad ABDUL ALHAZRED, speak of the great god CTHULHU, who will one day assume world dominion with his heavenly hosts.

The sleeping gods are supposed to lie in burial chambers deep in the bowels of the earth and in the depths of the sea.

One monitor reported strange goings-on inside the great Cheops pyramid in Egypt. It had been closed to tourists – officially for renovation – even before the catas-

trophe. Large piles of debris were continuously growing in front of the entrance, as if excavation works were being carried out, or as if the corridors leading to the Great Gallery (which somehow recalls an outsized launching ramp) were being widened. Special equipment was used to try and locate the movements inside, but then Cairo was flooded and the waters almost reached the lower, man-made corridor. The monitors – members of the army – disappeared without trace. Later, during the night, movement on the summit was observed from a submarine. Accompanied by the noise of a heavy strongroom door starting to open, the pyramid appeared to sink even lower. As if the eye of God decorating the dollar bill was disappearing. Then a deep rumbling was heard, and an object left the peak travelling at almost the speed of sound, too fast to be recorded.

The farsighted have unfortunately never yet been able to help prevent a catastrophe. Prophets of catastrophes are rarely popular, and indeed are often accused of having secretly prepared the way for misfortune when it occurs. A visionary artist, Abdul ARH+, who was inside the pyramid in 1987, long before the catastrophe, subsequently visualized the layout of the old part as recorded in plans.

In the illustration the artist has applied the cross-section of a Walther pistol to the Great Gallery and King's Chamber. The relief chambers above the King's Chamber correspond to an enormous silencer. The

Cthulhu Rising, 1989, marker pen on paper, 30 × 21 cm

proportions of the rising gallery dictate the size of the armed robots with glasses squatting in place of cartridges. Their height of 8.53 m corresponds to the size of gods as we conceive them. There is only one flaw: when a cartridge is fired only the bullet is released, in other words only the head.

Collage: cross-sectional view of the Cheops pyramid with integrated child-bearing machine

President of the Swiss Hell's Angels

▷ Sketches for poster, 1989
grease and felt pen on paper, 35 × 24 cm

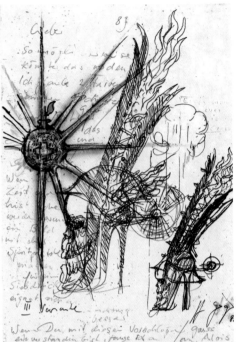

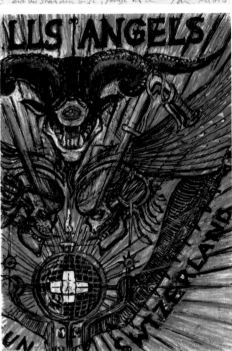

The Biker

It was Alex Schraner, loner and close friend of the »Hell's Angels of Switzerland«, who encouraged me to design the poster for the 10th international Hell's Angels meeting in Agasul. My fascination with the Hell's Angels went back some twenty years, as testified by an ink drawing from 1967, and so I was delighted to meet Hell's Angel president Black. With the creative support of Lex, I enthusiastically began to experiment with my paint pens – with successful results. But I was unfortunately not to see the printed end-product until two days before the event – and I was horrified. My originally luminous colours were as dull and flat as a pancake; what a disgrace! I was ashamed to hand over such a bad piece of work to a world-wide organization, but there wasn't enough time for corrections. That very night, therefore, after I had been allowed – as the only non-member – to attend the celebrations, I started airbrushing the printed sheets with a colourful, transparent ink, and the quality immediately improved. Should any of the 300 guests ever come back to Switzerland, there is a free, hand-finished copy ready and waiting.

▽ *The Hell's Angels*, 1967, ink on transcop on paper/wood, 44 × 24 cm

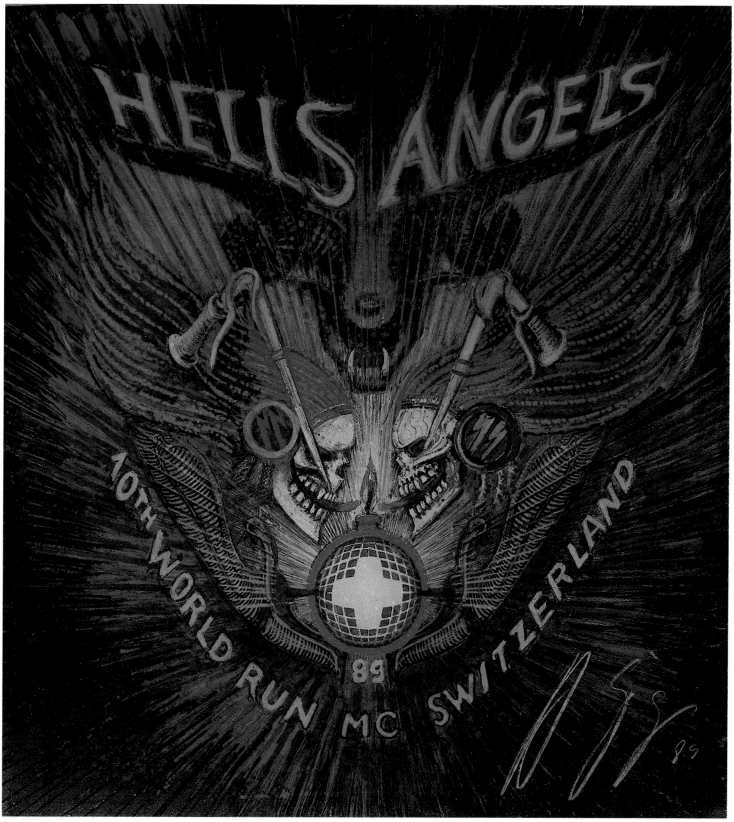

The Hell's Angels poster (blue version) for the 10th World Run, Switzerland, 1989, hand-coloured poster, 45 × 43 cm

Biography

1940–1962

Born on 5. 2. 1940 in Chur.
1945–46 Attends nursery school, first the Catholic Marienheim and then (after a quick change) Auntie Grittli's Reformational kindergarten.
1947–53 Attends junior school.
1953–57 Attends the cantonal school in Chur – two years of grammar school plus two years of technical school.
1957–58 Institut Haute Rampe, Lausanne.
1958–59 Alpina college, Davos – preliminary certificate in Drawing.
1959–62 Practical training with the architects Venatius Maissen, Chur, and the developer Hans Stetter, Chur.

Military college in Winterthur – as a mortar firer with the light motorized troops.

1962–1970

H.R.G. attends the School of Applied Arts in Zurich, Interior Design and Industrial Design department (one foundation year followed by three more specialized years). Produces ink drawings, his so-called *Atomkinder* (Nuclear Children), tachist pictures and his first works in polyester, primarily masks. In 1962 H.R.G. takes part in his first show in the Galerie Störchler, Basle. His ink drawings are published in underground magazines such as *Clou* and *Agitation*. He prints a number of works privately under the title *Ein Fressen für den Psychiater* (A perfect case for the shrink). In 1966, having graduated from the School of Applied Arts (with a diploma as an interior designer and industrial designer), H.R.G. starts working as a designer for Andreas Christen. He shares an apartment with the actor Paul Weibel, through whom he meets the beautiful actress Li Tobler and falls madly in love. First one man show in the Galerie Benno, Zurich. In 1967 H.R.G. meets the writer Sergius Golowin and the film-maker F.M. Murer. He features in Urban Gwerder's "Pötenz-Schau" in *High*, a 10-minute film documentary on his pictures made by F.M. Murer. Fred E. Knecht, proprietor of the Galerie Obere Zäune, includes pictures and objects by H.R.G. in his exhibition "Macht der Masken" (Power of the Mask).

In 1968 Basilio Schmid, known as Pascha, an old friend from Chur, persuades H.R.G. to give up his nine-to-five job with Andreas Christen. F.M. Murer commissions him to produce props for the planned 30-minute film *Swiss-made*. Gallery-owner Bruno Bischofberger buys a series of ink drawings and oil paintings. He advises H.R.G. to number and photograph all his works. H.R.G. takes part in the exhibition "Hommage à Che" in the Galerie Stummer, Zurich. In 1969 H.R.G.

Biomechanoiden, 1969. Portfolio of 8 screen prints, black on silver, all signed and numbered in an edition of 100 + XX. 100 x 80 cm (edition partially destroyed by fire). Published by Bischofberger, Zurich. Printed by Steiner, Zurich.

makes his first and, to date, last excursion into theatre with costumes and make-up for the actors in Edward Bond's *Early Morning*, a Peter Stein production in the Zurich Schauspielhaus. Happening in Jörg Stummer's gallery entitled "First Celebration of the Four", with Sergius Golowin and Friedrich Kuhn. Exhibitions in Austria and Germany. In 1970 H.R.G. buys a house with a garden in Oerlikon, Zurich. He and Li Tobler move into the new house in April. The Galerie Bischofberger shows H.R.G.'s *Passagen* (Passages).

1971

ARh+, the first catalogue of H.R.G.'s work, published by Walter Zürcher Verlag, Gutendorf, Berne (out of print)

F.M. Murer has been living in London for over a year. A reason for H.R.G. and Li to visit England. Murer and H.R.G. decide to make a documentary film called *Passagen* on H.R.G.'s pictorial world. London's mysterious docklands provide the first locations.

1972

The Kassel Kunstverein holds an exhibition of H.R.G.'s work. H.R.G. works on various series: *Passagen*, *Skin Landscapes* and psychedelic airbrush environments.

1973

Friedrich Kuhn – for H.R.G., one of Switzerland's greatest artists – dies. He was a frequent guest at Li and Eveline's in 1969/70 and usually spent the night sleeping on the kitchen table. H.R.G. and Kuhn were bound by a deep friendship and mutual admiration. For the Zurich art world, Kuhn was a master of the art of living. Using an airbrush to retouch a series of photos taken of Kuhn shortly before his death, showing the "Magus" sitting on his favourite sofa, H.R.G. creates the picture *Hommage à Friedrich*.

H.R.G. is commissioned to design a record cover for the English rock group Emerson, Lake & Palmer.

During a two-week "retreat" H.R.G., in collaboration with Claude Sandoz and Walter Wegmüller, creates *Tagtraum* (Daydream).

1974

The Bündner Kunstmuseum publishes a catalogue of H.R.G.'s works under the title *Passagen* (out of print)

Tagtraum is exhibited at the Bündner Kunstmuseum. The atmosphere of the "retreat" during which it was jointly created is captured in a documentary film by J.-J. Wittmer.

1975

Passagen-Tempel (Passage Temple), a work which H.R.G. has expressly created for the Galerie Sydow-Zirkwitz, is subsequently exhibited in the foyer of the Bündner Kunstmuseum.

Jörg Stummer encourages Li to open her own gallery in rooms adjoining his. She shows Manon, Pfeiffer and Klauke. At her last exhibition, entitled "Schuhwerke" (Shoe Works), where the guests are invited to appear at the vernissage in way-out shoe creations, H.R.G. wears a pair of "shoes" hollowed out of fresh loaves of bread and films the guests for the documentary *Giger's Necronomicon*. This film is produced in collaboration with J.-J. Wittmer. After this artistic stir, Li falls back into a state of lethargy and ends her life with a bullet.

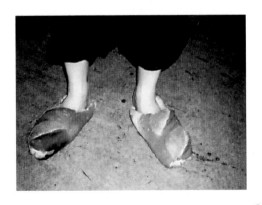

On 5 February. H.R.G.'s birthday, the new Galerie Sydow-Zirkwitz opens in Frankfurt with an exhibition specially designed for its rooms. The accompany-

1976

Catalogue to the H.R.G. exhibition at the Galerie Sydow-Zikwitz in Frankfurt (out of print)

ing catalogue illustrates all the works and includes a lengthy text by Professor Albert Glaser.

The nine-year relationship with Li, which ended so painfully with her death, leaves a terrible emptiness in H.R.G.'s life.

"The Second Celebration of the Four" is held amongst H.R.G.'s circle of friends at Ueli Steinle's Ugly Club in Richterswil; it is a happening which simultaneously represents the inauguration of the club and a memorial for Li.

Through contact with the American painter Bob Venosa, which leads via Salvador Dalí to Alexandro Jodorowsky, author of the films *El topo* and *Holy Mountain*, H.R.G. is commissioned to collaborate on the film *Dune*.

From a script by Moebius, H.R.G. designs the world of the "Harkonnens".

1977

H.R. Giger's Necronomicon, Sphinx Verlag, Basle, 1977 and 1978; new editions as *H.R. Giger's Necronomicon 1*, Edition C, Zurich, 1984, and Edition C, Zug, 1988 (all softcover) and 1991 (first hardcover edition). Licensed editions: Humanoid Assoc., Paris, 1977 (out of print), Big O, London, 1980 (out of print), Treville, Tokyo, 1987, and Morpheus International, L.A. 1991 and 1992

Second Celebration of the Four, 1977. De luxe edition of *H.R. Giger's Necronomicon*; clothbound presentation box with embossed title and 8 fold-out sheets, all issues signed and numbered in an edition of 150, of which nos. 1-10 contain a hand-finished photo (original). 42 x 40 cm. Printed by A. Uldry, Hinterkappelen

First trip to America. Travels to New York accompanied by friend and gallery-owner Bijan Aalam and Sybille Ruppert, in H.R.G.'s eyes one of the best representatives of fantastic erotic painting.

Takes part in the exhibition "Images of Horror and Fantasy" organized by Professor Gert Schiffer in the Bronx Museum, New York. Works from the years 1973–77 are shown in the Zurich Kunsthaus. The *Dune* film project fails to find a financial backer in the USA.

H.R.G. is commissioned by Dan O'Bannon to create the monster for the science fiction horror film *Alien*. The initial project is only a preliminary trailer intended to help O'Bannon find a film company willing to risk US$ 9 million on a final production.

1978

Alien, 1978. Portfolio of 6 screen prints in four colours, all signed and numbered in an edition of 350. 70 x 100 cm. 100 portfolios released for sale. Published by H.R. Giger and 20th Century Fox. Printed by A. Uldry, Hinterkappelen

At the beginning of the year H.R.G. meets Mia Bonzanigo, later to become his wife. The *Alien* project has found a Hollywood producer with ample financial resources in the form of 20th Century Fox. At the start of February, director Ridley Scott and two producers from 20th Century Fox visit H.R.G. in Zurich. *Giger's Necronomicon* has only recently (autumn 1977) been published in French and German; the director and the 20th Century Fox are shown one of the first copies, and the men from the film company are convinced that H.R.G. is the right man for the future project. The "big bosses" from 20th Century Fox inform H.R.G. of the conditions and financial arrangements regarding the film. Four hours later the ordeal is over and the gentlemen travel back to the USA. 20th Century Fox finances an *Alien* portfolio of six screen prints, which H.R.G. hands over, signed and numbered, to the vehicles of the film's publicity.

1979

H.R.G.'s contract allows him to be called in to promote the film. For this purpose he travels with Mia to Nice for the European première, and from there to London and Paris. Weeks later to New York, after a stopover in Dallas for a total of 23 TV interviews in one day, where he finally turns up, stressed and depressed, just in time to attend the preview in Hollywood in the company of Mia, Timothy Leary, and his wife Bar-

bara. The official release takes place two days later in Graumann's Egyptian Theater on Sunset Boulevard. The huge "space jockey", specially created for the film, is brought out from England and displayed in front of the cinema. It is later the victim of a pyromaniac attack.

H.R. Giger and Ridley Scott, Shepperton Studios, 1979

H.R.G. and Mia give inteviews for up to five hours a day. H.R.G. thereby develops a real "*Alien* interrogation allergy". After this mega-trip, H.R.G. and Mia marry.

1980

Giger's Alien, Sphinx Verlag, Basle; Edition Baal, Paris; Big 0, London, 1980 (softcover, all out of print); Treville, Tokyo, 1987. New editions: Edition C, Zug, 1989, 1992, 1995 (hardcover); Titan Books, London and Morpheus International, L.A., 1990

Erotomechanics, 1980. Portfolio of 6 screen prints in 8 colours, all signed and numbered in an edition of 300. 70 x 100 cm. Published by H.R. Giger. Printed by A. Uldry, Hinterkappelen

The designs and pictures for the film *Alien* are shown first in Zurich, in the Galerie Baviera, and then in the Musée Cantonal des Beaux-Arts in Lausanne. H.R.G. is nominated for an Oscar.

Short stopover in New York in order to attend the opening of H.R.G.'s exhibition in the Hansen Galleries, New York.

Bob Giuccione has published H.R.G.'s erotic pictures in a fourteen-page colour article in the American *Penthouse*, and now sponsors the extravagant exhibition opening. On 14 April in the Dorothy Chandler Pavilion, H.R.G. is awarded an Oscar for Best Achievement for Visual Effects for his contribution to the film *Alien*.

1981

H.R.Gigers *N.Y. City* pictures are inspired by his five trips to New York and an important template which his colleague Cornelius de Fries brought back home with him from one of his excursions into the electronics industry.

Since spring 1979, in a specially-rented studio near H.R.G.'s home, de Fries has been working on a technically highly-complex chair design, part of the "Harkonnen" furnishings for the film *Dune*.

1982

N.Y. City, 1982. Portfolio of 5 screen prints in eight colours, all signed and numbered in an edition of 350. Published by Ugly Publishing, Richterswil. Printed by A. Uldry, Hinterkappelen

In Zurich, a table (a variation of the chair) and a mirror frame have now been added to the furniture programme. These are exhibited and tested in the Nouvelle restaurant. H.R.G. and Mia divorce after c. 1¹/₂ years. They remain good friends. In autumn H.R.G. begins designing the preliminary trailer for *The Tourist* for the Universal film company. In collaboration with director Brian Gibson, he produces seventy sketches and eleven large pictures. Cornelius de Fries builds a situation model on a scale of 1:100.

1983

The series of *Victory* paintings, in part sprayed with day-glow paints, leads to the *Totems*: naked, technical posts crowned by a screaming head, rising up from a devastated landscape. A lithograph entitled *The Mexican Bomb Couple* is similarly a starting-point for a series of bomb pictures. H.R.G. is invited to be guest of honour at the Madrid and Brussels festival of fantastic films. The film project *The Tourist* having been put aside following the huge success of *E.T.*, H.R.G. is invited to Munich by Horst Wendtland, head of Rialto Films, to discuss a film version of *Momo* taken from the children's book by Michael Ende.

A film group from Paris produces a screenplay which is based on specific pictures by H.R.G. and which uses the title *Passage*. A further project, *The Mirror*, another horror film from 20th Century Fox, is also under discussion.

H.R.G. begins a series of small-format sheets, 48 x 34 cm, in which he uses his perspective templates for the

H.R. Giger on the cellar stairs at his parent's house in Chur

first time. Relief concrete floor slabs by H.R.G. are manufactured in de Fries's studio.

A new picture frame is produced, similar in design to the furniture programme.

1984

Seedam-Kulturzentrum bulletin on the H.R. Giger retrospective, 1984

H.R. Giger, Retrospektive 1964–1984, ABC Verlag, Zurich, 1984 (out of print)

Retrospective in the Pfäffikon Kulturzentrum; exhibition catalogue published by ABC Verlag. Film on the retrospective by Daniel Freitag and Rolando Colla. Ron Moore, director of *Future Kill*, persuades Giger to design the posters for his film. The posters are published by Ed Neal, the legendary *Texas Chain Saw Massacre* actor.

Collaboration with Martin Schwarz. Approx. fifteen pictures are produced. Friendship with Marlyse greatly influences Giger's image of women.

1985

H.R. Giger's Necronomicon 2, Edition C, Zurich, 1985 (in France distributed with a booklet of the text in French by Edition Baal, Paris (out of print)). New edition by Edition C, Zug, 1988 (softcover) and 1992 (first hardcover edition). Licensed editions: Treville, Tokyo 1987; Morpheus International, Los Angeles, 1992

Commissioned by MGM to create various horror scenes for the film *Poltergeist II* under director Brian Gibson. On 18 December 1984 H.R.G. and his manager fly to Los Angeles. H.R.G. is signed up for the film. Giger's colleague C. de Fries, signed up by Richard Edlund (Boss Film), tries to push through as many of Giger's ideas as possible. De Fries is only permitted to produce models, however.

On 23 May 1985 filming starts on location, a supermarket in the desert near Los Angeles. Giger and Steinle meet Julian Beck, the terminally-ill head of the former Living Theater. H.R.G. realizes he's working on the wrong film. Too late! When he signed his contract, no one had been willing or able to give H.R.G. any details of *Alien 2*, going into production at the same time.

The first scenes of *Poltergeist II*, written by Michael Grais and Mark Viktor, make a professional impression. H.R.G. is nevertheless worried about the quality of the final product, since the storyline is weak and Richard Edlund's special effects have not yet been filmed.

H.R.G. is commissioned by Volvo to produce an illustration for Isaac Asimov's short story *The Route to Hyperspace*. In Zurich, Edition C reprints *Necronomicon 1* and 2. The de luxe edition in an embossed cover contains an original lithograph, printed by the legendary Max Winistorf, who died shortly afterwards.

"BD" comic-strip festival in Sierre in Valais canton.

1986

Preparations for a large exhibition in the galleries of the Seibu Museum of Art in Tokyo in February 1987. Both *Necronomicon 1* and 2 and *Giger's Alien* are translated into Japanese and published by Treville.

Catalan Communications publishes the first English translation of *Necronomicon 2*.

Commissioned by the Swiss TV channel DRS to design a TV prize, the

"Prix Tell". C. de Fries produces the model to designs by H.R.G.

In Japan Sony launches the first laser discs with cover motifs by H.R.G. Alexander Bohr films a 45-minute portrait on "The fantastic universe of H.R. Giger" for the German TV channel ZDF. *Poltergeist II* is released worldwide. The film is a box office hit in the States, but in Europe soon disappears from the screen. H.R.G. is very unhappy with the visual transformation of his ideas.

1987

H.R. Giger's New York City, Sphinx Verlag, Basle, 1981; Ugly Publishing, Richterswil, 1981 and Edition Baal, Paris, 1981 (all out of print), Treville, Tokyo, 1987

Exhibition in Japan 87 H.R. Giger, published by the H.R. Giger Fan Club in Japan, 1987

Exhibition in Japan organized by the Seibu concern, Tokyo. In addition to the themes of *Giger's Alien* and *Poltergeist II*, the show includes the original *Alien* monster, a Harkonnen chair and other original pictures. H.R.G. paints a *Japanese Excursion* series especially for this exhibition. A Japanese Giger fan club is founded (H.R. Giger Fan Club, Biomechanoid 87 (Thoru Itho), D35-302, 1-2 Fuzishiro-Dai, Suita City, Osaka, 565 Japan).

There are talks on projects for Japanese-language editions of existing books (*Alien, Necronomicon 1* and *2*) and the printing of six different motifs as posters, plus a cover for a laser disc. Plans are also discussed for the building of a Giger bar in Tokyo. H.R.G. is commissioned to create the monster Goho Dohji for a film by the Japanese director Akio Jitsusoji.

1988

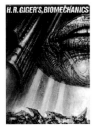

H.R. Giger's Biomechanics, Edition C, Zug 1988 (softcover). Licensed editions: Treville, Tokyo, 1989; Morpheus Int., Los Angeles, 1990 and 1992

After the exhibition in Japan, the main Giger books – *Giger's Necronomicon 1* and *2* and *Giger's Alien* – are translated. The Japanese Giger fan club issues a limited edition of 100 signed and numbered copies of their annual publication. A ten-volume edition of A. Crowley and individual works by Lovecraft and T. Leary are published in slipcases with Giger motifs. Due to strict planning laws, the four-storey Giger bar planned for Tokyo only retains fragments of the original concept. Despite Giger's qualms the bar is built, and opened by Ueli Steinle. Exhibition at Jes Petersen's gallery in Berlin. Takes part in an "Alchemy Symposium" in St. Gallen. His book *Biomechanics* is published by Edition C, Zurich, Peter Baumann; Bijan Aalam, Paris (with text supplement in French); and Morpheus International, Los Angeles, James R.Cowan (with text supplement in English). "Drawings Expanded" exhibition at Rolf Müller's Galerie Art Magazin.

1989

Giger uses relief-type elevations as a means of bringing more life into the structure of his colour pictures. Produces illustrations for Pier Geering's *Robofok* story, lettering by Daniel Affolter, and first colour comic strips for *Strapazin* and other magazines. Negotiations with A. Schraner lead to a club-only poster for the 10th international Hell's Angels meeting in Agasul, Switzerland. Negotiations on *Alien 3* and talks with Ridley Scott on a new film. Publication of the Japanese edition of *Biomechanics* (Yuji Takeda, Tuttle-Mori, Treville, Tokyo). Involvement in *Engel, Teufel und Dämonen* (Angels, Devils and Demons), a five-hour film on fantastic art

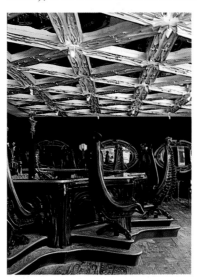

The Giger Bar in the Kalchb hlcenter, Chur, Tel. 00 41 81 27506. Photo: Willy Spiller

by Heinz Dieckmann. Giger writes down his reminiscences for Taschen. Exhibition in Château Yverdon as part of the PR for the first European SF museum, "Les Amis d'Ailleurs", which will be opened in 1991 as part of the 700th anniversary celebrations of the founding of the Swiss Confederation. Participates for the third time in the "Fête des Morts" at Rolf Müller's Art Magazin gallery. Collaboration on a cultural magazine with Bettina and Hans Klink in Zurich.

1990

H.R. Giger's Necronomicon 1 + 2, edition of 666 bound in black leather in a presentation box, signed and numbered with an original lithograph on the title page (printed by Walo Steiner), with the first 23 copies including a hologram (produced by Kühne & Partner, Switzerland). Published by Morpheus International, Los Angeles 1990

H.R. Giger celebrates his fiftieth birthday. Works on Ridley Scott's film *The Train*. Scott, however, postpones the film.

Preparations, with the energetic assistance of Etienne Chatton and Barbara Gavrisiak, for the exhibition "Alien dans ses Meubles" taking place in the Château de Gruyères from May to September.

Breaks away from his long-time manager, Ueli Steinle.

Designs a bag for the Migros Group, which is printed one million times.

Various exhibitions in the Bündner Kunsthaus in Chur in honour of his birthday. "Kunst und Krieg" in Berlin. Drawings in Guarda and in Nyon. He designs one side of a gold coin to the value of Sf. 250 for the Crush Alba restaurant in Guarda, which is used as a voucher for a meal for two people.

Makes various iron casts of old sculptures. Participates in the making of various documentary films, including *Gens de la Lune* for the television programme "Viva" by C. Delieutraz, *Telé ciné Romandie*" by André Blanchoud and for Japanese television.

Further work with Mia Bonzanigo.

Designs furniture for a café in Chur and a bar in New York in collaboration with T. Domenig, Chur and H. Matsunaga, Tokyo. The most important project this year, however, is the design work for the American film *Alien 3*. This is a mutation of *Alien 1*. Preparatory work for ART 1991 in the Gallery Hilt in Basle.

Enquiries from Disney Imageneering about future joint projects.

Works on his own film project, *The Mystery of San Gottardo*. An accompanying book, a mixture of cartoon and illustrated novel, also takes shape. H.R.G. regards this year as very important.

1991

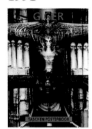

H.R. Giger Posterbook. Portfolio of 6 prints in four colours. Taschen, Cologne, 1991

H.R. Giger ARh+. Taschen, Cologne 1991. English, German, Italian, Spanish, Dutch, Swedish

700 Jahre warten auf CH-1991. Accordion-folded portfolio of 50 original lithographs, all signed and numbered (nos. 1–75 on special paper, nos. 76–300 on ordinary paper) in an edition of 300. Published by H.R. Giger. Printed by Walo Steiner, Asp, 1991

Design work for the film *Dead Star* for Bill Malone. Exhibition "Les Livres d'Esquisse" at Macadam – la M.J.C. de Cluse, Cluse. *ARh+* book vernissage at the Galerie Art Magazin, Zurich. H.R.G. is visited by Peter Steiner and A.Bürki from Swatch, Biel. Interviewed for *Warten* magazine by R. Stoert and D. Bordan. At the Basle art fair Art 22'91, Gallery Hilt holds a "One Man Show" with "swatched" Maxiwatches from H.R.G.'s *Watch Abart.* The exhibition "H.R.G.'s Biomechanic Visions" opens in Davos with a talk by Jörg Federspiel. The documentary *Alien 1–3* by Paul Bernhard, including an interview with H.R.G., is published by CBS/20th Century Fox, together with the laser disc *Alien 1*, which includes documentary material and an interview with H.R.G. The *Giger Library Room* is opened at the Maison d'Ailleurs, Yverdon.

1992

The Mystery of San Gottardo. Parts I-IV, Part XII and Part XIII, published by Atoz Editions as supplements to the comic magazine *Sauve qui peut*, Geneva, 1992

Dark Seed. Computer game, Cyberdreams, L.A., 1992

H.R. G. Skizzenbuch 1985. Museum Baviera, Zurich, 1992

H.R. Giger's Baphomet Tarot. Portfolio book of 24 zinc lithographs of drawings in an edition of 99. Printed by Walo Steiner, Asp, 1992

The H.R. Giger Calendar of the Fantastique 1993. Morpheus International, Los Angeles, 1992

On 8 February the Giger Bar opens in the Kalchbühlcenter, Chur. The proprietor is Thomas Domenig. Finnish television and Juhani Nurmi make the 30-minute documentary *Giger's Passage to the Id* in Davos, Chur, and at Walo Steiner's in Asp; Jörg Federspiel gives another interview for the programme. H.R.G. is interviewed in the Giger Bar for a BBC "Omnibus" programme on Ridley Scott.

H.R.G. meets Roman Güttinger, one of the largest collectors of *Alien* d cors. H.R.G. takes part in the Swiss Television programme "Dynamix". Launch of the computer game *Dark Seed*, published by Cyberdreams (Patrick Ketchum) with visual landscapes by H.R.G. Work on the Zodiac Fountain. Large H.R.G. retrospective opens in the Museum Baviera.

H.R.G. writes a short story on his occult experiences, which appears in the book *ARh+* published by Taschen. Paul Grau subsequently features the story – about the devil's head in H.R.G.'s collection – in the programme "Unsolved Mysteries", broadcast by the German television corporation RTL. Giger is given the 16 mm film *Sex, Drugs and Giger*, a $4^{1}/_{2}$-minute animation based on his pictures, by Sandra Beretta and Bätsch. The *Baphomet Tarot* created by H.R.G. and Akron for A.G. Müller of Neuhausen/
Rhine is premiered in the Giger Bar in Chur and in the Museum Baviera, Zurich.

1993

Baphomet – Das Tarot der Unterwelt. Pack of tarot cards designed by H.R. Giger/Akron for AG M ller, CH-8212 Neuhausen a. R., Switzerland. Edition with book, 1993; edition with abridged book, 1993. German, English and French

H.R. Giger's Watch Abart '93. New York and Burgdorf. Exhibition catalogue. H.R.G. and ARh+ Publications, N.Y.C., Leslie Barany, 1993

H.R. Giger Postcardbook. Taschen, Cologne, 1993

The H.R. Giger Calendar of the Fantastique 1994. Morpheus International, Los Angeles, 1993

"Alien" exhibition opens in the Museum Baviera, Zurich. Roman Göttinger shows a large selection from his private collection. The exhibition is chiefly devoted to *Alien 3*. One man retrospective in the Galerie Humus. Interview with ARTE TV. One man show in the Galerie Herzog, Büren zum Hof. From August onwards H.R.G. works with S. Beretta on the projects closest to his heart, in particular the books. Swatch decide not to collaborate with H.R.G. as earlier planned. One man show entitled "H.R. Giger's Watch Abart '93" staged in the Galerie Bertram, Burgdorf, and in the Alexander Gallery, New York. The latter show is coordinated by Leslie Barany, who also edits the catalogue *H.R.Giger's Watch Abart '93.*

1994

The H.R. Giger Calendar of the Fantastique 1995. Morpheus International, Los Angeles, 1994

Sascha Serfoezoe and Mia Bonzanigo assume charge, on H.R.G.'s behalf, of exhibitions in German, French and Italian-speaking locations. One man show entitled "Watch Abart" in the Galerie Mangisch, Zurich; one man show in the Galerie Ecllisse, Locarno. H.R.G. is guest lecturer for a term at the GBMS College of Design in Zurich. In February he starts work on the film *Species* for MGM.

Takes part in exhibitions in the Galerie Hartmann, Munich, at the Tattoo Convention in Bologna, and in the festivals "Fetisch & Kult", Tempel, Munich, and "Du Fantastique au Visionnaire" in Venice. H.R.G. starts planning a museum to present his work in all its scope. Begins work on the ghost train for *Species*, in collaboration with Atelier de Fries and Andy Schedler of Form Art.

1995

Baphomet – Das Tarot der Unter-welt. AG Müller, CH-8212 Neuhausen a. R., Switzerland. Edition with abridged book and CD, 1995. German, English and French

Cat. to the exhibition of works by H.R. G with S. Ruppert, from the P. Walter collection, Giessen Kunsthalle, 1995

Screensaver, Cyberdreams, L.A., 1995

Dark Seed II. Computer game. Cyberdreams, L.A., 1995

H.R. Giger ARh+ 3D 1996 Calendar. Taschen, Cologne, 1995

The H.R. Giger Calendar of the Fantastique 1996. Morpheus International, Los Angeles, 1995

H.R. Giger Set. Folder comprising 1996 ARh+ 3D calendar, blankbook, addressbook and Postcardbook. Taschen, Cologne, 1995

H.R. Giger 1996 Diary. Taschen, Cologne, 1995

H.R. Giger's Species Design. Morpheus International, Los Angeles, 1995; Edition C, Zug, 1995; Titan Books, London, 1995; Treville, Tokyo, 1995

H.R. Giger's Film Design. Edition C, Zug, 1996. Licensed edit.: Morpheus Int., L.A., 1996; Titan Books, London, 1996; Treville, Tokyo, 1996 (in preparation)

S. Serfoezoe takes over editorial duties for H.R.G. The ghost train is transported to L.A. One man show as part of the "13me festival du film fantastique" in Brussels. One man show in the Giessen Kunsthalle ("Konfrontationen") with Sybille Ruppert. Other exhibitions include "Le Train Fantôme" in the Maison d'Ailleurs, Yverdon; "Synaesthesia", Mary Anthony Galleries, New York; Psychedelic Solution Gallery, New York; "Abitare il Tempo, Delirium Design", Verona. Continues work on *Species*, the horror science fiction film

by Roger Donaldson after the screenplay by Denis Feldman and produced by Frank Mancuso jr. for MGM, Los Angeles. For the film, H.R.G. designs an extraterrestrial beauty and the ghost train. The film is released in the USA in July and is MGM's biggest success to date: box office takings are US$ 17.1 million in one weekend alone. H.R.G.'s work on *Species* inspires him to build a garden railway, which he creates as an outdoor sculpture. He starts constructing a $7^1/4$"-gauge railway in his garden. He is helped in this by new friends such as Harry Omura, Florian, André Margreitner, Stahl & Traum, Ball & Sohn, Robert Christoph junior, Marco Poleni, Fritz Rütimann, Andy Stutz and Tanja Wolfensberger.

H.R.G. and Sandra Beretta tackle

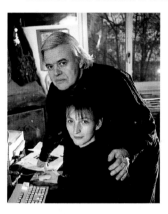

H.R. Giger and Sandra Beretta, 1995. Photo: Willy Spiller

several book projects, including the book accompanying the film *Species*, published before the year is out, and another book on all Giger's film designs. Both of these books are edited by Leslie Barany, New York, and James R. Cowan, L.A. Leslie Barany collects photographs of tattoos featuring Giger motifs for a book entitled *Giger under your Skin*.

H.R.G. also works with Sascha Serfoezoe on a comprehensive book on his *Mystery of San Gottardo* project. Together with computer graphics specialists Fabian Wicki in Berne and Pan Vision, Essen, H.R.G. creates 3D images for a 1996 Taschen calendar.

Work starts on an extensive Giger monograph to be published by Taschen. Zurich, Kunsthaus: "Illusion, Emotion, Realität", a centenary exhibition celebrating 100 years of film, staged by Dr. Harald Szeemann. Further exhibitions in Vienna, Venice and Barcelona. Alain Gegauf becomes H.R.G.'s friend and adviser.

One man shows

1966
Zurich, Galerie Benno

1968
St. Gallen, Galerie vor der Klostermauer

1969
Zurich, Galerie Platte 27, "Biomechanoiden"

1970
Zurich, Galerie Bischofberger, "Passagen"

1971
Berne, Actionsgalerie (with Schwertberger)

1972
St. Gallen, Galerie Look (Dibi Däbi)
Biel, Galerie 57
Baden, Trudelhaus (with Schuhmacher)
Kassel, exhibition by the Kunstverein

1973
Zurich, Galerie Stummer und Hubschmid
Cologne, Inter Art Galerie Reich

1975
Chur, Bündner Kunsthaus, "Passagen-Tempel"
Zurich, Galerie Baviera, complete graphic works
Zurich, Meier's Gallery of Modern Art

1976
Frankfurt, Galerie Sydow-Zirkwitz
Amsterdam, Galerie Kamp
Paris, Galerie Bijan Aalam
Regensberg, Neue Wohngalerie, complete graphic works
Richterswil, Ugly Club, "The Second Celebration of the Four"

1977
Zurich, Zürcher Kunsthaus
Biel, Galerie Baviera
Paris, Galerie Bijan Aalam

1978
Glarus, Kunsthaus (with Claude Sandoz)
Büren a.A., Galerie Herzog, complete graphic works

1979
Zurich, Galerie Baviera, works for the film *Alien*
Amsterdam, Galerie Kamp
Paris, Galerie Bijam Aalam

1980
Cavigliano, Galerie Baviera, "H.R. Giger sul tema dell' erotismo"
Zurich, Modelia-Haus, works for the film *Alien*
Lausanne, Musée Cantonal des Beaux-Arts, works for the film *Alien*
New York, Hansen Galleries, works for the film *Alien*

1981
New York, The Museum of the Surreal and Fantastique Biel, Kunsthauskeller

1982
Winterthur, *N.Y. City* pictures and the Bijan Aalam collection
Paris, Kunsthalle Waaghaus

1983
Basle, Art 14'83; Munich, Galerie Hartmann; Zurich, Steinle; Bonn, Galerie Klein, with Martin Schwarz; Cologne, Galerie am Severinswall, with Martin Schwarz

1984
Pfäffikon SZ, Seedamm-Kulturzentrum, "Retrospektive"
Basle, Art 16'85, with Martin Schwarz; New York, Limelight, "The Dune you will never see"; Biel, Galerie 58, Silvia Steiner, with Martin Schwarz

1985
Sierre, Maison Pancrace de Courten, "Retrospective"
Zurich, Galerie a 16
Nuremberg, "Zukunftsräume"

1986
Büren zum Hof, Galerie Herzog

1987
Zurich, Werkstatt-Galerie, Paul Nievergelt

1988
Zurich, Galerie Art Magazin, "Drawings Expanded"
Berlin, Galerie Petersen Rorschach, Museum im Kornhaus, graphic works
Zug, Wickart, graphic works
New York, Psychedelic Solution Gallery, paintings and prints
St. Gallen, Stadttheater, "Essenzia-Symposium for Alchemy"

1989
Chur, Galerie Plana Terra, graphic works

1990
Chur, Bündner Kunsthaus, exhibition on the occasion of H.R.G.'s 50th birthday. Exhibition of the 12 H.R. Giger pictures in the museum's collection
Gruyères, Château de Gruyères, "Alien dans ses Meubles"
Wettlingen, Informatikschule, pictures and graphic works

Guarda, Restaurant Crush Alba, drawings for *The Mystery of San Gottardo*
Nyon, Gallery Carré Blanc, drawings

1991
Cluse, Macadam – la M.J.C. de Cluse, "Les Livres d'Esquisses"
Zurich, Galerie Art Magazin, *ARh+* book vernissage Basle, Art 22'91, Gallery Hilt, "One Man Show"
Davos, Painthouse Academy, Window 92, "H.R. Giger's Biomechanic Visions"

1992
Zurich, Museum Baviera, "Giger-Retrospektive"

1993
Zurich, Museum Baviera, retrospective and works for *Alien* and *Alien 3*

Lausanne, Galerie Humus, retrospective and exhibition of *Swiss Transit Tunnel* works
Büren zum Hof, Galerie Herzog
Fürth, Galerie P17, drawings for *The Mystery of San Gottardo*
Burgdorf, Galerie Bertram and former Restaurant Krone, pictures and retrospective of sculptural works, including *Watch Abart* pieces
New York, Alexander Gallery, "Retro-NY", pictures and retrospective of sculptural works, including *Watch Abart* pieces

1994
Zurich, Galerie Mangisch, "Watch Abart"
Locarno, Galerie Ecllisse
Zurich, Odeon, "Communication Art Zürich"

1995
Brussels, 13ème festival du film fantastique
Giessen, Kunsthalle, "Konfrontationen", with Sibylle Ruppert (works from the Paul Walter collection)

Group exhibitions

1962
Basle, Galerie Stürchler

1967
Zurich, Galerie Obere Zäune, "Macht der Maske"
Berne, Kunsthalle, "Science-Fiction"

1968
Zurich, Galerie Stummer & Hubschmid, "Hommage à Che"
Zurich, Galerie Obere Zäune, 5th anniversary show
Erlangen, Galerie Hartmut Beck

1969
Vienna, Künstl. Volkshochschule, "Junge Schweizer Maler"
Zurich, Wenighof, "Kritische Realismen"
Zurich, Helmhaus, "Phantastische Figuration in der Schweiz"
Zurich, Galerie Stummer und Hubschmid, "Edition 12x12"
Berlin/Zurich, "Zürcher Künstler"

1970
Basle, Galerie Katakombe
Basle, Galerie G.
Geneva, Galerie Aurora
Lausanne, Musée des Arts de la Ville, "L'Estampe en Suisse"
Kassel, Studio-Galerie des Kunstvereins

1971
New York, Cultural Center, "The Swiss Avant-Garde"
Geneva, "3e Salon de la jeune gravure suisse"
Zurich, Strauhof, "5 Kritiker zeigen Kunst"
Basle, Art 2'71
Paderborn, Pädagogische Hochschule, "Editionen"
Cologne, Internationale Kunst- und Informationsmesse
Zurich, Strauhof, "Zürcher Zeichner", Ars ad interim
Chur, Bündner Kunsthaus, "Neueingänge 70/71"

1972
Glarus, Galerie Crazy House
Zurich, Züspahallen, "Zürcher Künstler"
Zurich, "Freiheit für Griechenland"
Zurich, Strauhof, "Werk & Werkstatt"
Cracow, "Biennale internationale de la gravure"
Basle, Art 3'72
Lucerne, Verkehrshaus, "Künstler-Verkehr-Visionen"
Bradford, Third British International Print Biennale
Tel Aviv, "Contemporary Swiss Art"
Zurich, Jerusalem, Haifa, "Zürcher Künstler"

1973
Berne, Basle, Lugano, Lausanne, Geneva, "Tell 73"
Basle, Art 4'73
Zurich, Biennale im Kunsthaus, "Stadt in der Schweiz"
Schaffhausen, Museum zu Allerheiligen, "Kunstmacher 73"
Oberengstingen, "Spektrum 73"
Berne, Galerie für kleine Formate, "small size"
Düsseldorf, IKI, Internationaler Markt für aktuelle Kunst

1974
Winterthur, Geneva, Lugano, "Ambiente 74"
Zurich, Strauhof, "66 Werke suchen ihren Künstler"
Chur, Bündner Kunsthaus, "GSAMBA Graubünden"

Olten, Kunstverein, "Zürcher Fantasten"
Munich, Galerie Jasa GmbH & Co. Fine Art
Frankfurt, Galerie Sydow, inaugural exhibition
Basle, Art 5'74
Chur, Bündner Kunsthaus, "Tagtraum", together with C. Sandoz and W. Wegmüller
Zurich, Kunsthaus, "Tagtraum"
Winterthur, Kunstmuseum, "Tagtraum"
Olten, Kunstmuseum, "Tagtraum"
Paris, Galerie J.C. Gaubert, "400 Ans de Fantastique"
Zurich, Galerie Li Tobler, "Manon oder das lachsfarbene Boudoir"
Düsseldorf, Kunstmesse IKI 74

1975
Zurich, Galerie Li Tobler, "Schuhwerke"
Basle, Art 6'75
Paris, Galerie Bijan Aalam, "Le Diable"

1976
Nuremberg, Kunsthalle, "Schuhwerke"
Zurich, Villa Ulmberg, "Zürcher Künstler"
Amsterdam, Galerie Kamp, "Fantastisch Realisme"
Zurich, Strauhof, "Zwischen Konflikt und Idyll"
Zurich, Hamburg, Berne, Paris, S.R. Baviera, "DIN A4"
Paris, Galerie Espaces 76, "3 Espaces"
Paris, Galerie Bijan Aalam, "Le Vampire"

1977
Lausanne, Musée Cantonal des Beaux-Arts
Basle, Art 8'77
New York, Bronx Museum, "Images of Horror and Fantasy"
Tours, "Multiple 77"
Liège, Arts à Saint-André
Zurich, Galerie Baviera, "Echo vom Matterhorn"
Zurich, Galerie Stummer, "Kleinformate"
Zurich, Strauhof, "Das Menschenbild"
Burgdorf, Galerie Bertram
Zurich, Züspa-Hallen, "Kunstszene Zürich"
Paris, Galerie Bijan Aalam, "Le Miroir"

1978
Vienna, Künstlerhaus am Karlsplatz, "Kunstszene Zurich"
Chur, Bündner Kunsthaus, "GSAMBA Graubünden"
Winterthur, Kunstmuseum, "3. Biennale der Schweizer Kunst"
Winterthur, "Aktualität Vergangenheit"
Zurich, Galerie Baviera, "Tagtraum", with C. Sandoz and W. Wegmüller
Zurich, Centre Le Corbusier, "Atomkraftwerkgegner-Komitee"
Basle, Art 9'78
Bochum, Museum, "Imagination"

1979
Olten, Kunsthaus Olten (Galerie Baviera), "Vorschlag für ein anderes Museum"
Basle, Art 10'79
Rennes, Maison de la culture, "L'Univers des Humanoïdes"

1980
Zurich, Kunsthaus Zürich, "Schweizer Museen sammeln Kunst"
Winterthur, Kunsthalle im Waaghaus, "Vorschlag für ein anderes Museum"
Basle, Art 11'80
Lausanne, Musée Cantonal des Beaux-Arts, "Schweizer Museen sammeln Kunst"
Zurich, Helmhaus, "Transport, Verkehr, Umwelt"
Los Angeles, Hansen Galleries, "Art Expo West"
Zug, Kunsthaus, "Die andere Sicht der Dinge"
Le Havre, Maison de la culture (Pro Helvetia), "Quelques Espaces Suisse 80"
New York, Hansen Galleries, "Art 1980", International Fair of Contemporary Art
Glarus, Kunsthaus, "Die andere Sicht der Dinge"
Lille, Palais Rameau, "Science au Future"

1981
Ohio, School of Art (Hansen Galleries), "Science Fiction and Fantasy Illustration"
Basle, Art 12'81
Chicago, The Picture Gallery, "Space Artistry"

1983
Munich, Galerie Hartmann, Villa Stuck, "Eros und Todestrieb"
Laax, Galeria d'art
Basle, Galerie J. Schottland

1984
Kassel, Orangerie, "Zukunftsräume"

1986
Nuremberg, "Der Traum vom Raum" (catalogue)
Zurich, Galerie Art Magazin, "Ausstellung Tutti Frutti"
Zurich, Galerie Art Magazin, "Fest der Toten 'Unter dem Vulkan'"
Dortmund, Museum am Ostwall, "Macht und Ohnmacht der Beziehungen" (catalogue)
Olten, Kunstmuseum, Collection Baviera"
Zurich, Galerie a 16, Fred Knecht

1987
Lausanne, Galerie Basta, "Fête des Morts"
Shibuya Seed Hall, 21-1, Udagawacho, Shibuya-ku, Tokyo

Shinsaibashi Parco Studio, 1-45, Shinsaibashi Suji, Minami-ku, Osaka. Saibu Hall, 2-3-1, Minooham, Otsu-shi.
Shiga Pref., SF exhibition featuring *Alien* works in four museums in Tokyo and three other cities

1988
Martigny, Les Caves du Manoir, "Fête des Morts"
Frankfurt, Book Fair, Kunsthalle, Edition C
Zurich, Shedhalle, "Kunst Woher Wohin"
Zurich, Museum für Gestaltung, "Kunstszene Zürich"

1989
Frankfurt, Book Fair, Kunsthalle, Edition C
Zurich, Galerie Art Magazin, "Accrochage"
Yverdon, Château Aula Magma, "Les Amis d'Ailleurs"
Zurich, Galerie Art Magazin, "Fête des Morts"

1990
Zurich, Helmhaus, "Ankäufe 1988"
Geneva, MJC St. Gervais, "Ailleurs est proche"
Berlin, Haus der Kulturen der Welt, "Kunst und Krieg"
Paris, Galerie d'Art Dmochowski, "Les Visionnaires"
Montreux, Musée du Vieux Montreux, "Fête des Morts"

1991
Lausanne, Galerie Humus, "Les Inconnues"
Chur, Jugendhaus, "Comix-Ausstellung
Zurich, Helmhaus, "Verwandtschaften"
Yverdon, Maison d'Ailleurs, "Giger's Library Room"; converted prison cells with paintings, furnishings and *Alien* accessories
Martigny, Le Manoir, "Fête des Morts"

1992
Seville, Expo 92, Papellon de Suiza, "Unerwartete Schweizer"

1993
Basle, MUBA, "Movie World", exhibition including H.R.G.'s film designs (pictures and Harkonnen furniture)
Zurich, re-opening of Galerie Art Magazin
Zurich, Museum der Seele, "More Pricks than Kicks"
Gruyères, Château de Gruyères, "Le Tarot"
Zurich, Museum der Seele, "Day of the Dead"

1994
Zurich, Galerie Art Magazin
Zurich, Galerie a 16, "Ufo & Ifo"
Zurich, Galerie Mangisch, "Lucifers Rising"
Munich, Galerie Hartmann
Munich, Tempel, "Fetisch & Kult"
Venice, "Du Fantastique au Visionnaire"
Lausanne, Galerie Humus, "Les Sexe des Anges"
Bologna, Tattoo Convention

1995
Arbon, Schloss Arbon, "Migros-Säcke"
Zurich, Galerie Art Magazin, 10th anniversary show Zurich, Galerie Tumb, "Zyklorama"
Paris, Stardom Gallery, "Les Anges"
Yverdon, Maison d'Ailleurs, "Le Train Fantôme"
New York, Mary Anthony Galleries, "Synaesthesia"
New York, Psychedelic Solution Gallery
Lausanne, Galerie Rivolta, "Magie Noire"
Gruyères, Château de Gruyères, "Le Zodiaque des signes dans votre ciel"
Zurich, Kunststrasse, H.R. Giger's 3D images
Verona, "Abitare il Tempo, Delirium Design"
Zurich, Kunsthaus, "Die grosse Illusion. Die 7. Kunst auf der Suche nach den 6 anderen."
Vienna, Messepalast, "Invasion der Ausserirdischen", and in ten other German and Austrian cities Lausanne, Galerie Humus, "Rosée d'Eros"
Zurich, Galerie Tumb, "Unrat"

1996
Venice, Vienna, Barcelona, "Die grosse Illusion. Die 7. Kunst auf der Suche nach den 6 anderen."
Milan, Arteutopia, "Suoni & Visioni"

Works in permanent collections/on permanent display

Chur, Bündner Kunsthalle, paintings and sculptures
Chur, Kalchbühlcenter, Giger Bar, furniture and interior design by H.R. Giger, architect Thomas Domenig
Tokyo, Giger Bar on four floors, designed by H.R. Giger
Yverdon, Maison d'Ailleurs, SF museum with "Giger's Library Room"; converted prison cells with paintings, furnishings and *Alien* accessories
St. Gallen, Restaurant Haus zur letzten Laterne, *700 Jahre Warten auf CH-91* portfolio and sculptural works

Work in film, television and theatre

1967
High und Heimkiller, film contribution to U. Gwerder's "Poëtenz-Shau"; 16 mm, 11 min., magnetic sound, in collaboration with F.M. Murer

1968

Swiss-made, 2069, collaboration on a science fiction film by F.M. Murer; 35 mm in colour, 45 min., sound-on-film

1969

Early Morning, collaboration on a Peter Stein production in the Zurich Schauspielhaus

1972

Passagen, colour film about H.R.G. by F.M. Murer for the German broadcasting corporation WDR, Cologne; 50 min., sound-on-film, special prize for Best TV Film at the Mannheim film festival

1973

Tagtraum, colour film by Jean-Jacques Wittmer about the psychedelic meeting of the three artists C. Sandoz, W. Wegmüller and H.R.G. in Sottens; Basle, 28 min., magnetic sound

1975

Giger's Necronomicon, colour film on the work of H.R.G. from 1972–75 by J.-J. Wittmer and H.R.G.; 16 mm, 40 min.

1976

Décor designs for A. Jodorowsky's 70-mm colour film *Dune,* after the prize-winning book of the same title by Frank Herbert (film later realized by David Lynch without H.R.G.)

1977

Giger's Second Celebration of the Four, film fragment by J.-J. Wittmer and H.R.G.; 16 mm, magnetic sound, 5 min.

1978

Alien, 117 min., horror science fiction motion picture by Ridley Scott after the screenplay by Dan O'Bannon, Brandywine prod., Los Angeles, 20th Century Fox, Los Angeles/London

1979

Giger's Alien, documentary film on Giger's work for Alien; 16 mm in colour, 34 min., magnetic sound. Produced by M. Bonzanigo, H.R. Giger and J.-J. Wittmer

1981

H.R. Giger's Dream Quest, by Robert Koputt; BCM video recording on 1" tape; 40 min., interview and video animation; Koo-Koo, promotion film by H.R. Giger for Debbie Harry, c. 6 min.

1982

A new face of Debbie Harry, documentary film by F.M. Murer, magnetic sound, 30 min.

1986

Poltergeist II, 87 min., motion picture by Brian Gibson after the screenplay by Michael Grais and Mark Viktor, MGM prod., Los Angeles
H.R. Giger designs the "Prix Tell", prize for Swiss artists awarded annually by the Swiss TV corporation DRS

1988

Teito Monogatari, 135 min., motion picture by Akio Jitsusoji after the book by Hiroshi Aramata, Japanese prod.

1990

Alien 3, 112 min., motion picture by David Fincher, 20th Century Fox, Los Angeles
The Mystery of San Gottardo, own motion picture project by H.R. Giger (in development)

1991

Alien 1-3, documentary by Paul Bernard, includes material and interviews with H.R. Giger. Prod. CBS/ 20th Century Fox
Alien 1, laser disc, includes documentary films of and an interview with H.R. Giger
Horror Hall of Fame Awards, includes documentary film by H.R. Giger

1992

Satanskopf, film for the German TV series "Ungelöste Geheimnisse" (Unsolved Mysteries), drawing upon a short story of the occult by H.R. Giger
"Wall to Wall", BBC documentary on cyberpunk films featuring interviews with H.R. Giger, William Gibson and Bruce Sterling
"Omnibus", H.R. Giger interviewed on director Ridley Scott; BBC, London
Giger's Passage to the Id, 30 min., documentary by Altro Lahtela and Juhani Nurmi for Finnish television
Sex, Drugs and Giger, 16 mm colour film, 4 ¹/₂ min., animation by Sandra Beretta and Bätsch for the Solothurn film festival

1993

"Brother to Shadows". *The Alien World of H.R. Giger,* documentary by Morpheus Int. dir. by David Frame and prod. by James R. Cowan and Clara Höricht-Frame (in development)

1995

Species, 110 min., horror science fiction film by Roger Donaldson after the screenplay by Denis Feldman, prod. by Frank Mancuso jr. for MGM, Los Angeles
Benissimo, 6'04", ballet for 5 dancers in a 3D installation of Giger pictures. Written and directed by Max Sieber. Prod. by the Swiss TV corporation DRS

Prizes and awards

Inkpot Award, San Diego Comic Convention, 1979
Academy Award, Oscar for Visual Effects in *Alien,* 1980
Readercon Small Press Award, best interior illustrator and best jacket illustration, Los Angeles, Morpheus International, 1991
The Ink-credible Tattoo Award, New York, Tattoo Convention, 1993
Merit Award, Grisons, 1994

Original prints issued as portfolios

Ein Fressen für den Psychiater, 1966. Artist's cardboard portfolio, screen print, 12 A4 reproductions, drawings, map print. Portfolio signed and numbered in an edition of 50. 42 x 31 cm (approx. 30 copies printed). Printed by H.R. Giger/Lichtpausanstalt Zurich.

Biomechanoiden, 1969. Portfolio of 8 screen prints, black on silver, all signed and numbered in an edition of 100 + XX. 100 x 80 cm (partially destroyed by fire). Published by Bischofberger, Zurich. Printed by Steiner, Zurich.

Trip-Tychon, 1970. Portfolio of 34 colour screen prints, all signed and numbered in an edition of 100. 100 x 70 cm (partially destroyed by fire). Published by Bischofberger, Zurich. Printed by Silkprint, Zurich.

Passagen, 1971. Portfolio of 4 multi-coloured serigraphs, all signed and numbered in an edition of 70 + XX. 90 x 70 cm (partially destroyed by fire). Published by Bischofberger, Zurich. Printed by Silkprint, Zurich.

Second Celebration of the Four, 1977. Clothbound presentation box with embossed title and 8 fold-out sheets, all issues signed and numbered in an edition of 150, of which nos. 1-10 contain a hand-finished photo (original). 42 x 40 cm. Printed by A. Uldry, Hinterkappelen.

Alien, 1978. Portfolio of 6 screen prints in four colours, all signed and numbered in an edition of 350. 70 x 100 cm, 100 portfolios released for sale. Published by H.R. Giger and 20th Century Fox. Printed by A. Uldry, Hinterkappelen.

Erotomechanics, 1980. Portfolio of 6 screen prints in eight colours, all signed and numbered in an edition of 300. 70 x 100 cm. Published by H.R. Giger. Printed by A. Uldry, Hinterkappelen.

N.Y. City, 1982. Portfolio of 5 screen prints in eight colours, all signed and numbered in an edition of 350. Published by Ugly Publishing, Richterswil. Printed by A. Uldry, Hinterkappelen.

Pilot in Cockpit and Alien Egg, Version II, 1978, in an edition of 1000, signed and numbered, 19¹/₂" x 27". Limited edition: Dark Horse, 1991

E.L.P II, Brain Salad Surgery, record cover, 26¹/₂" x 22¹/₂", 1973, + Debbie Harry, Koo Koo, triptych, 21¹/₂" x 34", 1981, LP cover art coll., 1991. 10,000 prints, of which 200 are signed and numbered.

E.L.P IX, 28" x 28" (picture 24" x 24") and *Biomechanoid,* 28" x 40" (picture 24" x 24"), 1991. Set of 24 colour prints, signed and numbered in an edition of 495. Published by Morpheus International.

700 Jahre warten auf CH-91, 1991. Accordion-folded portfolio of 50 original lithographs, all signed and numbered (nos. 1-75 on special paper; nos. 76-300 on ordinary paper), in an edition of 300. Published by H.R. Giger. Printed by Walo Steiner, Asp.

H.R. Giger's Baphomet Tarot, 1992. Portfolio book of 24 zinc lithographs of drawings, in an edition of 99. Printed by Walo Steiner, Asp.

Stier, Fisch and Zodiac-Brunnen, 1993. Zinc plate lithographs in five colours. Published by Morpheus International, Los Angeles. Printed by Walo Steiner, Asp.

Sil Tritychion, © H.R. Giger + MGM, 1995. Two-colour screen print, 90 x 120 cm, in an edition of 1/290 + EA. Published by Morpheus International, Los Angeles. Printed by A. Uldry, Hinterkappellen.

Species hinter den Kulissen, © H.R. Giger + MGM, 1995. Six-colour screen print, 90 x 120 cm. Edition A: 170 x 120 cm, 1/350 + EA, c. 200 commercially available, all signed and numbered. Edition B: 100 x 70 cm, 1/400 + EA, not commercially available, all signed and numbered. Published by MGM and H.R. Giger. Printed by A. Uldry, Hinterkappelen.

Special projects

Video clip by Odessa-Film C für Pioneer, Japan, 1985

Giger Bar, Tokyo, extending over four floors, 1988

Baphomet - Das Tarot der Unterwelt. Pack of tarot cards designed by H.R. Giger/Akron for AG Müller, CH-8212 Neuhausen a. R., Switzerland. Edition with book, 1993; edition with abridged book, 1993. Edition with abridged book and CD, 1995. German, English and French

Giger Bar, Kalchbühlcenter, Chur, 1992

Dark Seed. Award-winning computer game employing images based on H.R. Giger's works. Cyberdreams, Los Angeles, 1992

Screensaver, employing images based on H.R. Giger's works. Cyberdreams, Los Angeles, 1995

Dark Seed II. Computer game employing images based on H.R. Giger's works. Cyberdreams, Los Angeles, 1996

The H.R. Giger Calendar of the Fantastique, published annually since 1993 by Morpheus International, Los Angeles

H.R. Giger Set. Folder comprising 1996 3D calendar, blank-book, addressbook and Postcardbook. Taschen, Cologne 1995

H.R. Giger Diary. Taschen, Cologne 1995

H.R. Giger 3D Calendar 1996. Special edition as portfolio, signed and numbered, in an edition of 300 and 100 artist's copies, 1995

H.R. Giger's Species Design. Special leatherbound edition including zinc lithograph; Printed by W. Steiner, Asp 1996

h.R. Giger's Zodiac-Brunnen (in development)

Books on and by H.R. Giger

ARh+, by H.R. Giger, Walter Zürcher Verlag, Gutendorf 1971 (out of print)
Passagen, by H.R. Giger, Bündner Kunsthaus, Chur, 1974 (out of print)
Catalogue to the Giger exhibition, Galerie Sydow-Zirkwitz. Text by Horst A. Glaser, Frankfurt, 1976 (out of print)
H.R. Giger's Necronomicon, Sphinx Verlag, Basle, 1977 and 1978; new editions as *H.R. Giger's Necronomicon 1,* Edition C, Zurich 1984, and Edition C, Zug, 1988 (all softcover) and 1991 (first hardcover edition). Licensed editions: Humanoid Assoc., Paris, 1977 (out of print), Big O, London, 1980 (out of print), Treville, Tokyo, 1987, and Morpheus International, L.A., 1991 and 1992
Giger's Alien, Sphinx Verlag, Basle; Edition Baal, Paris; Big 0, London, 1980 (softcover, all out of print); Treville, Tokyo, 1987. New editions: Edition C, Zug, 1989, 1992, 1995 (hardcover); Titan Books, London and Morpheus International, L.A., 1990
H.R. Giger's New York City, Sphinx Verlag, Basle, 1981; Ugly Publishing, Richterswil, 1981 and Edition Baal, Paris, 1981 (all out of print), Treville, Tokyo, 1987
H.R. Giger, Retrospektive 1964-1984, ABC Verlag, Zurich, 1984 (out of print)
H.R. Giger's Necronomicon 2, Edition C, Zurich, 1985 (in France distributed with a booklet of the text in French by Edition Baal, Paris (out of print)). New edition by Edition C, Zug, 1988 (softcover) and 1992 (first hardcover edition). Licensed editions: Treville, Tokyo, 1987; Morpheus International, Los Angeles, 1992
H.R. Giger's Biomechanics, Edition C, Zug, 1988 (softcover). Licensed editions: Treville, Tokyo, 1989; Morpheus Int., Los Angeles, 1990 and 1992
H.R. Giger ARh+, Taschen, Cologne, 1991. English, German, Italian, Spanish, Dutch, Swedish
H.R. Giger Posterbook. Portfolio of 6 prints in four colours. Taschen, Cologne, 1991
H.R. Giger Skizzenbuch 1985, Museum Baviera, Zurich, 1992
H.R. Giger Postcardbook, Taschen, Cologne, 1993
H.R. Giger's Necronomicon 1 + 2. Collector's edition, German, 500 copies bound in black Pecorex, embossed, signed and numbered, and including the original lithograph *Back to Mother* (printed by Walo Steiner), Edition C, Zurich, 1985; edition of 666 bound in black leather in a presentation box, signed and numbered with an original lithograph on the title page (printed by Walo Steiner), with the first 23 copies including a hologram (produced by K hne & Partner, Switzerland). Published by Morpheus International, Los Angeles, 1990
Giger's Watch Abart '93. Catalogue of the exhibition in New York and Burgdorf. H.R. Giger and Arh+ Publications N.Y.C., Leslie Barany
H.R. Giger's Species Design, Morpheus International, Los Angeles, 1995; Edition C, Zug, 1995; Titan Books, London, 1995; Treville, Tokyo, 1995
H.R. Giger's Film Design, Edition C, Zug, 1996. Licensed editions: Morpheus Int., Los Angeles, 1996; Titan Books, London, 1996; Treville, Tokyo, 1996 (in preparation)

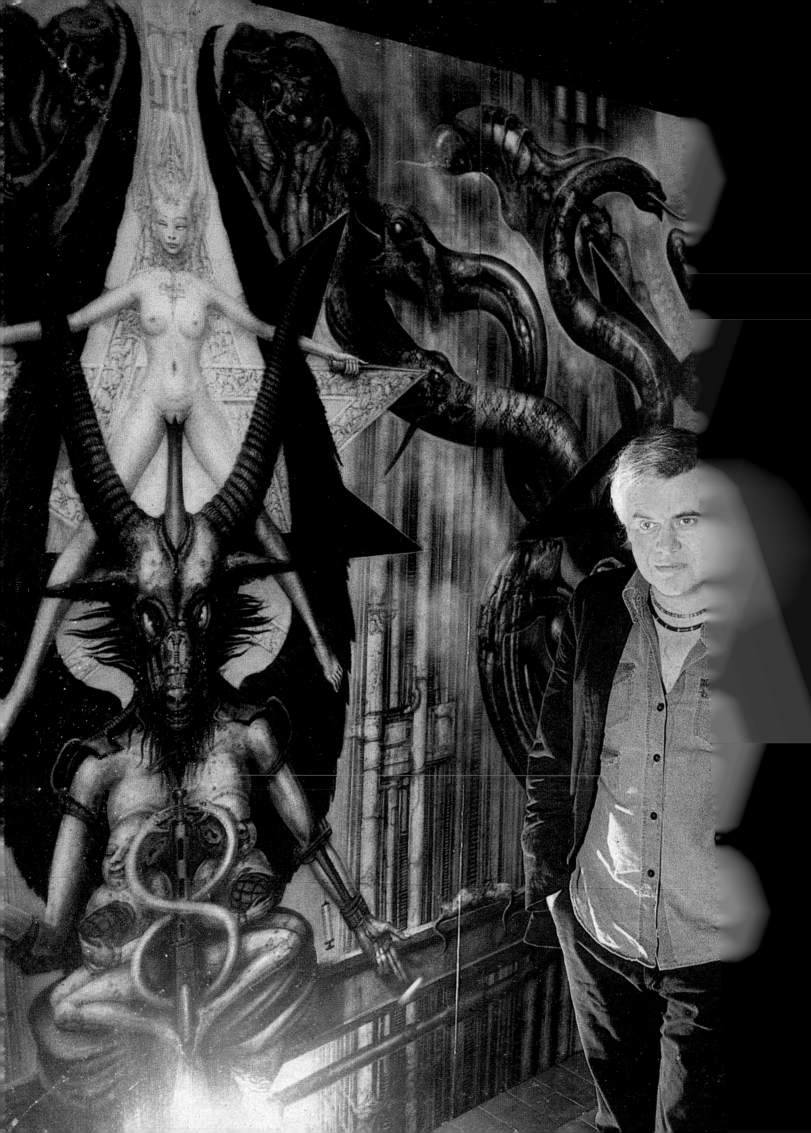